little book of

MiAMi
style

Text © Ashley Brozic 2025
Design and layout © Headline Publishing Group Limited 2025

Published in 2025 by Welbeck
An Imprint of HEADLINE PUBLISHING GROUP LIMITED

1

Cataloguing in Publication Data is available from the British Library

ISBN 9781035423798

Printed in Dubai

Headline's policy is to use papers that are natural, renewable and
recyclable products and made from wood grown in well-managed
forests and other controlled sources. The logging and manufacturing
processes are expected to conform to the environmental regulations of
the country of origin.

HEADLINE PUBLISHING GROUP LIMITED
An Hachette UK Company
Carmelite House
50 Victoria Embankment
London EC4Y 0DZ

The authorised representative in the EEA is Hachette Ireland,
8 Castlecourt Centre, Dublin 15, D15 XTP3, Ireland (email: info@hbgi.ie)

www.headline.co.uk
www.hachette.co.uk

ASHLEY BROZIC

little book of

MiAMi
style

W

WELBECK

CONTENTS

introduction page 6

chapter 1:

THE CiTY THAT STYLE BUiLT

page 14

chapter 2:

MADE iN MiAMi

page 34

chapter 3:

MiAMi DESiGNERS

page 50

chapter 4:

STYLE ESSENTIALS

page 74

chapter 5:

VICE & VERSACE: MIAMI IN POP CULTURE

page 88

chapter 6:

THE STYLE CAPITAL OF THE TROPICS

page 138

index page 158
credits page 160

iNTRODUCTiON

Neon lights, palm trees, art deco and around 50km (31 miles) of glamorous beachfront. The postcards have never lied: Miami is paradise. This is a city that has never known how to be anything but itself: unapologetically bold, seductively irreverent, delightfully hot and oh, so cheeky – in more ways than one.

In its short 130-year history, Miami has managed to cement itself in imaginations worldwide, and fashion has played no small role in making this happen. Think Don Johnson's pastel-hued suits in *Miami Vice*. Think the exuberant glamour of South Beach in the 90s. Think the colourful characters who descend upon this city every first week of December for Art Basel – whether to see art – or be seen as it. And throughout every decade, think too the vibrancy and fashion forwardness of what locals and visitors don year-round.

No single designer has ever defined Miami's style; rather, the city itself inspires design. Pulling reference from architecture, tropical terroir and the area's Latin and international influences, the world's most recognized sartorial names have launched entire lines inspired by Miami, from Marc Jacobs' collection for Spring/Summer '89 to Olivier Rousteing's Pre-Fall '24 release for Balmain, which builds upon his '13 Resort collection. Both feature dramatic art deco lines, kaleidoscopic pool mosaics and flamingos – all unmistakable markers of the Miami aesthetic.

But Miami's influence in fashion goes deeper than pastel hues and palm tree motifs. Because of its proximity to the Caribbean, South and Central America, it is often referred to as the "Gateway to Latin America". Like a cultural

Don Johnson's pastel-hued suits in *Miami Vice* helped to cement Miami as a style capital.

open-door policy, language, customs and style move fluidly across Florida's shores, imbuing the city with the richly diverse tapestry that has come to define it. Miami is probably the first interaction that many Caribbean and Latin American designers and fashion industry professionals have with the US market, making it a wonderful place to discover new talent and creativity from offshore.

Today, a growing number of designers and fashion industry professionals are choosing not just to visit Miami for inspiration or to use it as a launch pad, but to stay and influence the city's fashion industry themselves. New fashion schools and business resources are working together to create a strong fashion industry within the city, much like it was in the mid-twentieth century. In the near future, Miami won't just be somewhere to visit for inspiration or to shop for the latest luxury collections, but a place where talent can grow and thrive.

"Delightfully hot and oh, so cheeky – in more ways than one"

Palm trees, flamingos and dramatic art deco silhouettes: For his 2024 Pre-Fall collection, Olivier Rousteing built on his 2013 Miami-inspired release.

Opposite and above: Art Basel is the most fashion-forward week of the year in Miami, with both visitors and locals donning their most creative looks.

With the largest concentration of art deco buildings in the world, South Beach's 1930s architecture found new life in the 1980s and 90s, inspiring fashion and redefining the city's cultural identity.

Introduction

chapter 1

THE CiTY THAT STYLE BUiLT

Miami is a young city, in age as much as in attitude. Incorporated in 1896, it has the unique distinction of being the only major US city to be founded by a woman.

When wealthy Ohio native Julia Tuttle moved to South Florida in 1891, the tropical skyscape we now know as Miami was a wild swampland cohabitated by Seminoles, Bahamians and daring American homesteaders. Seeing its potential, Tuttle set out to turn this lush waterfront paradise into a formidable city. In exchange for hundreds of acres of land along the Miami river, she and another founding Miami family, the Brickells, convinced industrial tycoon Henry Flagler not only to extend his railroad to Florida's southernmost reach, but also to set up some of the city's initial infrastructure. And so, on this no man's land, where gators roamed the river and water outweighed earth, a paradisaical resort town was born.

Being a resort destination is as fundamental to Miami's DNA as mangroves and mosquitoes, and what's a resort without well-dressed guests? Though much has changed since Miami's founding, one thing has not: travelling here has always called for a trendy, warm-weathered wardrobe. During "season" in South Florida, which still runs from around Thanksgiving to Easter, there was golf to be played in the morning, sunbathing and yachting to be done in the afternoon, and galas and social events to attend by night. Miami and its northern neighbour, Palm Beach, were made for leisurely outdoor activities and social occasions. To be without the right attire would have been a travesty.

From its earliest days, Miami used style as a calling card, with department stores and manufacturers hosting glamorous poolside fashion shows to premiere next season's summer trends. Editors and buyers, flown in and wined and dined, left inspired – helping to cement the city as both a trendsetter and a must-visit destination.

Hollywood starlet and champion swimmer
Esther Williams takes a dip in a Miami pool
in the 1950s, shot by Slim Aarons.

THE PALM BEACH SEASON

Before the war, affluent travellers favoured the French and Italian coasts, but with conflict in Europe, Palm Beach rose as the "American Riviera", adding a fifth season to the fashion calendar: the "Palm Beach Season", according to the *New York Times* in 1928.

Clothes for the Palm Beach Season were different from what might be worn for spring and summer at home. They tended to be more whimsical, spun in colourful, lighter fabrics like crepe silk and jersey, and making use of techniques such as drapery and pleating, which allowed for movement.

Soon, couturiers such as Chanel, Lanvin and the House of Worth were designing winter collections with not just the Côte d'Azur in mind, but also Palm Beach. The enclave had such clout in the fashion industry that New York's most luxurious retail stores, Saks Fifth Avenue and Bonwit Teller, opened their second US locations here, as did international brands such as Cartier.

"Palm Beach is the birthplace of the resort category in the modern era," said Cameron Silver, the renowned vintage expert and fashion personality, speaking to *Women's Wear Daily*. "A Northerner completely abandons her all-black wardrobe when crossing the bridge for the season and pivots to bold prints and colors."

The City That Style Built

THE RiSE OF RESORTWEAR

If Palm Beach is responsible for igniting the sport and resortwear industry in America, Miami can lay claim to spreading its flames. Whereas Palm Beach was exclusively reserved for the unfathomably wealthy, Miami welcomed the middle class with open arms, thanks to a plethora of modest accommodations like the art deco hotels that have come to define South Beach.

Whereas the activities of Palm Beach socialites were painstakingly detailed in the Sunday papers, Miami offered visitors an air of acceptance and discretion, much like it does today. There were more relaxed rules for dress code and more room to take risks. An early example is the use of stockings under swimwear dresses. In Palm Beach, they were required. In Miami, it was best to leave them in your trunk.

"Miami was made to be marketed: lush, vibrant and humid," writes Dr Deirdre Clemente, fashion historian and Associate Professor at the University of Las Vegas, Nevada. "The clothes created in and for this city accommodate life there: backless dresses, canvas boat shoes, sandals, hats, beachwear and tennis shorts, which are a bit shorter than regular shorts."

Clothing needs in South Florida were more casual and leisurely than the rest of America. Its subtropical climate called for cooling fabrics that could withstand the heat, while the state's range of year-round outdoor activities, from sunbathing to sport, required clothing that facilitated movement.

A group of vacationers modelling typical
swim and resortwear of the 1940s.

In 1920s Florida, golfwear for women borrowed from
menswear's tailored aesthetics, introducing long-sleeve shirts,
box-pleated skirts and practical construction for movement.

Golf played a pivotal role in reshaping fashion, releasing men's attire from its more formal constraints. By the mid-1930s, many of the casual clothing articles allowed only on the green were now allowed in dining rooms: navy blazers, khaki pants, polos, deck shoes and shirts with tropical patterns. As women embraced golf, Florida's fashion scene responded with specially designed outfits that balanced mobility with style.

A 1926 article in *Vogue* declared sports dresses made of crepe satin as the daytime uniform of smart women in Palm Beach, accessorized by wing-tipped Oxfords or linen shoes. Short sweater dresses were a favourite, as were trousers in jersey fabric and skirts with box pleats – all of which allowed for movement and ease. Fussy dresses were seldom seen, and even pyjamas found their way out of the house and onto the beach. Colours tended to be pastel or bright, toned down by white, beige and tan. Patterns that skewed tropical and geometric were consistent trends. As for swimwear, one did not just purchase a bathing suit, but also the robe, overskirt, hat, sandals and sunglasses to go with it. It's no wonder resortwear became a category of its own; from the onset it was a huge money maker.

In the 1980s, Miami's resortwear influence received another popularity boost, thanks to *Miami Vice*. *Vogue* reported the emergence of "city resort", with designers taking their resort collections and infusing them with "an eye more towards turned-out city dressing than to vacation time". On the runways, everyone from Calvin Klein to Ralph Lauren was mixing summer fabrics like silk charmeuse and linen with more formal fabrics such as wool, imbuing their collections with dopamine-drenched colours that the magazine described as "Miami Vice" pales.

Above: In the 1970s, resortwear took on a more cosmopolitan, flashy edge.

Opposite: Model Karen Graham wears a white linen silk-
weave set by Bill Blass. Tropical power suiting was
a common trend in 1970s and 80s Miami.

SUMMER STYLE STARTS IN SOUTH FLORIDA

South Florida's influence on the global fashion industry goes beyond pastel colours and revealing silhouettes; it has always been a vital testing ground for spring and summer trends.

In 1930, *Womens' Wear Daily* noted: "The southern resortwear season serves as a kind of laboratory for research into the consumer reaction to the modes presented for warm weather wear. Invariably, the apparel types that prove outstanding at Palm Beach, Miami and elsewhere in the southland are popular later in the regular selling season." Other publications like the *New York Times* and *Vogue* echoed this. Northern department stores such as Macy's set up sections touting all anyone might need for a Florida getaway.

Miami's image as a style destination was no accident; it was entirely by design. Its chambers of commerce and tourism boards used style as a key selling point in building the city's glamorous image, pushing it as a soothsayer of summer styles early on. They, along with local retailers, aggressively published advertisements in the winter editions of luxury publications. "Many original trends in resort styles are defined and established during the smart Miami winter season," states a December 1930 placement in *Vogue*.

Miami-based department store Burdines played a vital role not just in driving tourism to South Florida, but in establishing Miami as a trendsetter for summer styles.

The City That Style Built

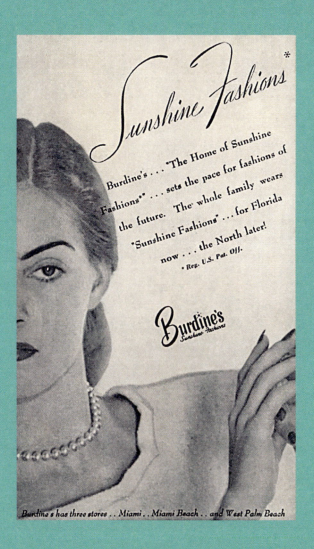

Sunshine Fashions *

Burdine's . . . "The Home of Sunshine Fashions*" . . . sets the pace for fashions of the future. The whole family wears "Sunshine Fashions" . . . for Florida now . . . the North later!

* Reg. U.S. Pat. Off.

Burdine's
Sunshine Fashions

Burdine's has three stores . . Miami . . Miami Beach . . and West Palm Beach

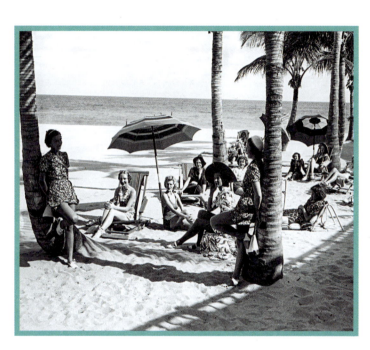

A Burdines fashion showcase at the Surf Club in 1945.

"Next summer's styles will be fixed here this winter – you'll have the jump on everyone by several months with your Miami wardrobe," declares another in 1937.

In 1941, the Miami Chamber of Commerce found itself so immersed in fashion promotion that it formed the Miami Manufacturers Guild, later renamed the Miami Fashion Council, to take the city's garment industry to new heights. Initially, the Guild sent representatives to New York to promote Miami's resortwear to buyers, but by the 1950s, Miami was hosting its own fashion shows, drawing in editors, journalists and buyers to their resort and sportswear-focused market weeks, where they were provided with rooms, travel and evening entertainment. They visited local showrooms and fashion shows, and saw first-hand how resortwear was worn throughout the city in day-to-day life. This influenced how editors would inform the rest of the country to dress that year, as well as what stores would be carrying up north.

Not only did the chambers have a hand in building the city's stylish reputation, they also played the key role in building an entire fashion and retail ecosystem. They pushed for lax tax codes, facilitated relationships with national department stores and carved out designated shopping districts like Lincoln Road to attract clothing manufacturers and retailers to set up shop in Miami. As early as 1929, notable department stores like Sears and others saw the value of opening outposts, and by 1966 the city had a plethora of shopping centres and malls to satisfy their retail whims, from the luxurious Bal Harbour Shops to more mainstream options like Dadeland Mall. Local retail executives were chamber members and helped to drive the city's reputation and industry, none more than those at Burdines, a department store so intertwined with the story of Miami, it would grow to become a byword for Florida style for many decades.

The City That Style Built

BURDINES: THE FLORIDA STORE

W.M. Burdine & Son opened in 1898 as a dry goods store in Downtown Miami, just two years after Miami was founded. From the start, it leaned on clever marketing to lure visitors to the new city, like covering the cost of train travel for shoppers who spent a certain amount. As Miami grew in prestige, the store evolved to meet the needs of its more affluent, style-conscious clientele. When William's son, Roddy, took the reins of the company in 1911, he transformed W.M. Burdine & Son from a trading outpost into a fashion-forward department store.

Roddy was a marketing maven and prominent community figure who delighted in creative techniques to drive business, from hosting orchestras in store to running ads in national publications encouraging visitors not to pre-shop, but to "bring your trunks empty!" Among his greatest contributions to the style ethos of Miami, however, was the launch of Sunshine Fashions, a brand of original, year-round summer styles exclusive to Burdines, designed for Florida's climate but versatile enough to be worn up north throughout the summer. "No longer does the fashion-wise woman select her entire resort wardrobe before reaching Florida," reads an ad in *Vanity Fair*. "It is only natural that Sunshine Fashions, Burdines' exclusive creations and adaptations ... should come to be known as America's Smartest Resortwear."

By the time Roddy died in 1936, Burdines had grown to be the largest volume retailer in the South-East. In 1948, it counted four stores across three counties. The downtown Burdines flagship was a lively social hub in Miami, offering amenities

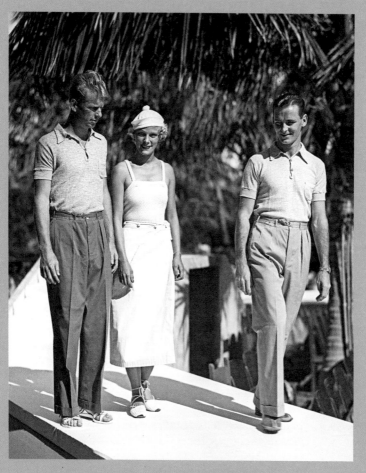

A group of models show off the latest
"Sunshine Fashions" for Burdines.

like beauty salons, travel departments and mail-order services for Latin American customers. At its peak, it ran 104 departments selling everything from tropical fruits to top tier furniture. At one point, there was even an art gallery in-store.

Backed by Federated Department Stores, which bought the company in 1956, Burdines expanded rapidly throughout the state in the decades to follow. By 1991, its number of stores had ballooned to 58 across the state. But despite all of its success, Burdines wasn't immune to corporate consolidation and changing retail habits. Federated acquired R.H. Macy & Co. in 1994 and a decade later, Burdines folded under the Macy's name.

The original Burdines department store in Downtown Miami.

Today, little physical remains of Burdines. The iconic "Sunshine Fashions" sign still lights up the facade of Macy's on Lincoln Road and in many Florida malls you can spot the Corinthian-esque columns of thick palm trees that ushered shoppers in. But longtime state residents and visitors fondly remember the department store. Dubbed "The Florida Store", it was the place that defined tropical style in America for over 100 years, popularizing resortwear, both directly and indirectly, throughout the twentieth century.

The City That Style Built

chapter 2

MADE iN MiAMi

While Miami may not be known for producing iconic designers like Ralph Lauren or Donna Karan, it has played a significant role in the American fashion landscape. In the mid-twentieth century, Miami was the third-largest garment manufacturer in the United States, behind New York City and Los Angeles, producing the very leisure and sportswear garments it helped to popularize.

The industry got its bearings in the 1930s, when Jewish entrepreneurs began relocating to South Florida, transforming the area's economy, especially in the garment trade. As many of them were in the garment trade in New York, they brought mass-production expertise to the city while Cuban women, especially after the Cuban Revolution in 1959, provided the skilled talent and labour, and by 1965, a network of 200 garment and accessories factories had grown across Dade County, with Cuban women making up 90 per cent of the workforce. By 1973, that number ballooned to 573 factories, producing everything from swimsuits to accessories to clothing, even for major brands like Lilly Pulitzer.

Though synonymous with Palm Beach, many of Pulitzer's most iconic prints were designed and made by Key West Hand Print Fabrics, then shipped to be sewn at her factory in Miami, which employed 200 workers at its peak. Other brands proudly stamped "of Miami" on their labels, such as Alix of Miami, known for glamorous cocktail dresses and swimsuits, and Midas of Miami, famous for its animal-shaped wicker purses. Cover Girl of Miami produced active sportswear, while The Twins Swimwear churned out stylish bikinis throughout the 70s and 80s that were sold nationwide.

The city's garment industry thrived thanks to a year-round production cycle, driven by South America's opposing seasons and Miami's ability to quickly test, produce and restock items. Local manufacturers could release small test runs and rapidly

Did someone call for a suit? Miami menswear designer Mal Marshall leans on leggy models to showcase his latest collection in the 1950s.

fulfil demand from nearby retailers like Burdines. And unlike in New York, where components of a single garment were manufactured at separate locations, in Miami, most factories could assemble everything under one roof.

Major retailers like Sears and JCPenney established regional offices in the city, granting Miami-based manufacturers widespread distribution opportunities in addition to the market weeks that were being hosted in Miami Beach. As L.W. Fairchild, publisher of *Women's Wear Daily*, noted: "The Miami name on a clothing label is beginning to pull a lot of weight all over the world" – which is why he opened a Fairchild branch in the city early on. Even Parisian couturier Pierre Balmain chose Miami to produce his American women's suiting line in 1951, underscoring the fine quality that the city's skilled labour could provide.

The showroom of
Alix of Miami was
designed by architect
Morris Lapidus, who
also designed the
iconic Eden Roc
and Fontainebleau
resorts.

Made in Miami

Swimwear in Miami is served with a side of glamour. Here, a bathing suit designed and made by Alix of Miami.

FABRIC INNOVATIONS

Miami is often cited as a diverse tapestry of cultures, but little do people talk about the fabrics it helped to popularize. In the late 1940s, Miami emerged as a leader in the production of cotton and linen clothing, capitalizing on year-round demand for these fabrics. With direct access to Southern textile mills, Miami had a clear economic advantage over its western rival, California.

While the rest of the world looked down on synthetic fabrics, Miami's leisure and sportswear industry embraced the growing popularity of man-made fibres like rayon, Orlon, nylon and Dacron. Integrating these materials into locally made designs highlighted the city's innovative approach to fashion. These fibres, emblematic of American ingenuity, were ideal for swimwear and sportswear, which demanded material that was form-fitting, breathable and easy to move in. Their affordability also made clothing more accessible, enabling the rapid spread of these ready-to-wear styles nationwide. Miami's garment producers were instrumental in popularizing these new materials, leveraging the city's trendsetting reputation to accelerate their adoption in the broader market.

Even today, Miami designers continue to innovate with fit and materials. For instance, Karelle Levy, who is known for her line of tropical knitwear called KRELwear, and Sigal Cohen, who hand-paints every pattern with watercolours for her resortwear label, SIGAL. Lanthropy, a Key Biscayne-based brand, experiments with metallic linen, creating pants and tops that emulate leather but are suitable for warmer climates.

Above: Though synonymous with Palm Beach, Lilly Pulitzer's
iconic patterns were designed in Key West and brought
to life in Miami's Allapattah neighbourhood.

Overleaf: While the rest of the world was slow to embrace synthetic
fabrics like rayon, nylon and Dacron, Miami adopted them with ease
– driven by the heat, relaxed dress codes and a need for mobility.

Made in Miami

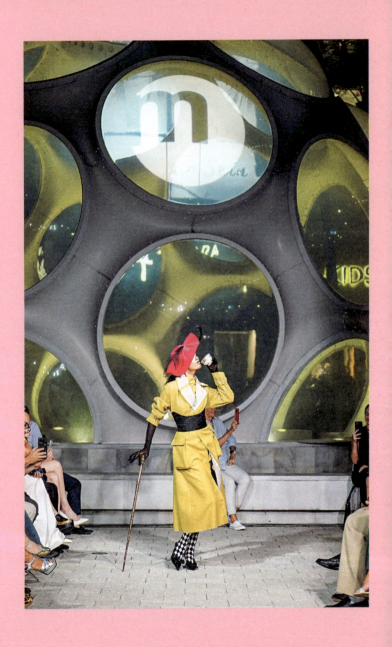

MiAMi'S FUTURE iS FASHiON

Miami's once-thriving garment industry, like many others across the US, began to decline in the 80s due to globalization and shifting economic policies. But while the majority of the city's garment production has moved offshore, efforts are underway to rebuild Miami's fashion infrastructure and reclaim its place in the industry.

Miami's fashion schools are playing a crucial role in developing local and international talent, reinforcing the city's emergence as a fashion hub. Institutions like the Miami Fashion Institute at Miami Dade College and Istituto Marangoni are cultivating the next generation of designers, stylists and fashion professionals.

"The culture of Miami is very open-minded, very welcoming," says Istituto Marangoni Miami President Hakan Baykam. "It's easier to shine for the young generation here instead of New York, Milan or Barcelona." He believes it's an ideal place for young designers to launch their careers without the overwhelming competition found in traditional fashion capitals. Istituto Marangoni, in particular, has been actively recruiting from Latin America through involvement in regional fashion weeks and offering scholarships to top talent from the region.

While cities like Los Angeles and New York are pricing their garment districts out, Miami aims to launch its own with platforms like Mana Fashion Services, a division of

Made in Miami

A student showcase from Istituto Marangoni held in the Miami Design District.

Mana Commons. Founded by real estate developer Moishe Mana, the project seeks to revitalize Downtown Miami into a hub for fashion, tech and culture. By providing spaces like designer studios, showrooms and a textile resource centre, Mana Fashion Services is uniting the city's disparate fashion community, which includes designers, manufacturers, stylists, models, photographers and more to build a sustainable and talent-fostering ecosystem. "Our fashion community is strong. There are a lot of people here designing, creating and working together, but it's all over the place," says Martu E. Freeman-Parker, Managing Director of Mana Fashion Services. "It's a connecting point for Latin designers and brands to enter the US market. That was Mana's initial concept, and we've discovered there's enough talent in Miami to create a central, professional district."

The fashion industry in Miami has even caught the attention of renowned designer Naeem Khan. In 2014, he announced plans to move his headquarters from New York to Miami, envisioning a campus that would include a manufacturing facility and an extension of Miami's Design and Architecture Senior High School (DASH). He sees Miami as the ideal location to bridge the fashion industries of Latin America and beyond, noting the similarities between Latin American and Indian craftsmanship. "Latin Americans are similar to Indians – you learn from your moms and grandmothers, whether it's arts and crafts, cooking or weaving. Even as an industry, I need people who sew and weave, and Latin America is leading in innovative fabrics like those made from pineapple and bamboo," Khan explains. He believes that by investing in Miami, other established and emerging designers will follow, helping to build the city's fashion ecosystem and keeping talent in the region.

Made in Miami

Designer Naeem Khan, a staunch supporter of establishing Miami's fashion industry, showcases his collection during Miami Fashion Week 2022.

chapter 3

MiAMi
DESiGNERS

Miami designers bring a fresh perspective to fashion, drawing inspiration from the city's lively culture, tropical terrain and rich Latin heritage. Whether they stay to build the local scene or take their talents worldwide, their impact injects a fun, easygoing and fashion-forward edge into the industry. Flip through the resortwear section of your favourite store and you'll likely find garments by these creators. Or look to the runways, where you'll see designers like Lazaro Hernandez or Esteban Cortázar subtly infusing their upbringing into collections – whether through a slightly sexier fit, bold colours, or just a dash of flash. Here are some designers bringing the stylish energy of Miami to the masses.

BREAKOUT STARS

Esteban Cortázar

Esteban Cortázar's fashion career is as multifaceted as his upbringing in 90s South Beach. "I grew up above the News Cafe," he recalls. "Versace would be having breakfast downstairs, and I'd say hi on my way to school." His early days living with his father on Ocean Drive were surrounded by a wild mix of personalities, from drag queens and go-go dancers to supermodels and designers, all converging in Miami's eclectic scene. "I was introduced to gay culture in a very open way as a little boy," he recalls, noting how the flamboyant fashion of the community left a lasting impression on him. His childhood memories are rich with experiences like watching the filming of *The Birdcage* and attending his first New York Fashion Week as a kid with designer Todd Oldham. "It was a very unique childhood and I'm very grateful for those times. It will always be a part of inspiration for my work."

Esteban Cortázar grew up in South Beach in the 90s with his father, an artist. In 2021, he released a capsule collection for Desigual featuring his father's designs.

Miami Designers

At 18, Cortázar became the youngest designer at NYFW, and by 22, he was creative director at Emanuel Ungaro. In 2015, he relaunched his label with a unique strategy: presenting collections to retailers during the Resort market, then showing them to the press on the regular runway schedule. His eclectic South Beach upbringing and love for nightlife influenced many of his designs, like his Spring/Summer 2016 collection, which channelled Miami's club scene with bold pieces like python bra tops and metallic leather gilets, and Spring/Summer 2017's skate- and surf-inspired looks.

His rise was rapid, with stars like Beyoncé wearing his designs, including a standout moment when she donned a yellow dress from his Spring/Summer 2003 collection on the cover of her 'Naughty Girl' single. "That collection was so Miami – tangerine and turquoise, the colors of the sea and the skin," he explains. His early work captured the essence of South Beach's sexy, playful energy, deeply inspired by the nightlife culture that surrounded him growing up.

Today, Cortázar is embarking on a new chapter with his label Donde Esteban, where he merges his multifaceted upbringing and diverse cultural influences into a collection that feels distinctly personal.

"SoBe has been on my moodboard in every collection that I've done."
Esteban Cortázar

Miami Designers

Model Alek Wek wears a yellow dress from Cortázar's South Beach-inspired debut collection.

Lazaro Hernandez

Proenza Schouler may have defined downtown New York City cool over the last two decades, but at least half of its roots are solidly steeped in Miami. Lazaro Hernandez, who co-founded the brand with Jack McCollough in 2002, often credits his Miami upbringing for sparking his love of fashion. Growing up, Hernandez spent countless afternoons in his mother's beauty salon in Coral Gables, watching glamorous women talk about their lives. "Hair, makeup and fashion were all topics of constant conversation," he once told *System* magazine. "I always had one eye on whatever boring book I had to read for school and the other fixed on these incredible creatures, one more beautiful and exotic than the next."

Hernandez initially pursued medicine at the University of Miami, but the reality of surgery pushed him to secretly apply to Parsons School of Design, where he and McCollough met in 1998. From the beginning, they had the support and instruction of some of the fashion industry's heavy players. It was Anna Wintour who referred Hernandez for an internship at Michael Kors, where he gained the knowledge he needed to run a fashion brand. The referral was a true stroke of fate; Wintour and he were on the same flight from Miami to New York, and he slipped her a napkin in first class, asking for advice. Proenza Schouler, a combination of the maiden names of the designers' mothers, launched almost immediately upon graduation when their joint thesis collection was purchased by Barneys New York.

Proenza Schouler quickly rose to prominence, winning the inaugural CFDA/Vogue Fashion Fund in 2004. Known for their refined, modern approach to womenswear, the duo has since earned multiple CFDA Womenswear Designer of the Year awards. They have an innate ability to play

Miami Designers

Proenza Schouler co-founder Lazaro Hernandez often cites his Miami upbringing for inspiring his love of fashion.

with geometric shapes, dramatic angles, wild prints and experimental fabrics, while still making them feel like everyday closet staples. Many of their garments and accessories reach cult status among the fashion set: their signature PS1 satchel launched in 2008 and became an emblem of wearable luxury.

FRESH TAKES

éliou

When Harry Styles needed a beachier version of his signature pearl necklace to splash around the Amalfi Coast for his 'Golden' music video, his stylist knew who to call. Founded in 2019 by childhood friends Duda Teixeira and Cristy Mantilla, éliou is a brand of handmade jewellery, ready-to-wear and accessories that capture the essence of beachcore Miami. Their pieces range from playful beaded necklaces to shell-embellished earrings, embodying a sense of nostalgia, youthful creativity and melting pot maximalism. Mantilla explains: "We design first for ourselves and then later offer those designs to our customers", a philosophy that drives their commitment to creating accessible, unique jewellery which just feels good to wear.

éliou's rise to cult status was sudden; they were picked up by Net-a-Porter even before their own website went live. Celebrities and their stylists became sudden fans; they count Kaia Gerber, Hailey and Justin Bieber, Gigi Hadid, Jennifer Lawrence and Ariana Grande as repeat customers. In 2023, they collaborated with Maje on a limited edition clothing collection. Today, the brand is sold at fashion-forward retailers like Moda Operandi, Saks Fifth Avenue, Nordstrom, Shopbop, Harvey Nichols and Kith, in addition to trendy boutiques and their flagship boutique in Miami's Little River neighbourhood.

Miami Designers

éliou's operations are a family affair. Teixeira's mother and aunts, who oversee production in Brazil, model the brand's SS23 RTW collection.

éliou has quickly become a celebrity favourite,
counting Harry Styles as a repeat wearer.

The company operations are a family affair, a fact that makes
the duo extremely proud and a dynamic to which they're
committed. While the majority of their jewellery is made by
a tight team of women at their Miami headquarters, their
ready-to-wear collections are produced in Brazil, where
they're overseen by family. Despite their international
recognition, the brand remains deeply connected to Miami,
infusing each collection with the tropical eclecticism of their
hometown. Every ear cuff, freshwater pearl or crocheted
dress embodies the carefree spirit of Miami while celebrating
craftsmanship and community.

Gabriel Salcedo

There's a sophisticated New York quality to the work of Miami-based designer Gabriel Salcedo, resulting in timeless garments made with impeccable tailoring and highly thought-out fabrics. Salcedo's aesthetic melds Miami's boldness with a sophisticated and refined urban edge, resulting in versatile, genderless pieces that encourage personal expression. Each collection is concise, heavy in neutrals and with statement pieces in a single pop of colour, which means customers can build upon each season. This reflects Salcedo's commitment to creating timeless clothing that transcends trends, inviting the wearer to infuse it with their own unique narrative.

Central to Salcedo's vision is a deep connection to his Dominican heritage, which informs his creative process and the personal symbols embedded in his designs. His journey into fashion began with a desire to create the perfect wardrobe, prompting him to start designing clothes after he moved to Miami from New York City during his adolescence. While working as a barber for celebrity clients, Salcedo quietly crafted his early pieces on the side, gaining the confidence to pursue his dream when rapper Meek Mill wore one of his designs. This pivotal moment in his career led to the establishment of his brand in 2016, which has been gaining traction ever since. In 2024, he made his Paris Fashion Week debut and won the RTW designer of the year from fashion incubator Mana Fashion Services. As he continues to evolve his brand, Salcedo remains dedicated to crafting pieces that embody both Miami's spirit and a modern luxury aesthetic.

Miami Designers

RESORT

Silvia Tcherassi

Dubbed a pioneer of Latin flair by *Women's Wear Daily*, Silvia Tcherassi helped establish the resort-inspired aesthetic that has come to define the view of Latin American fashion globally today. Originally from Barranquilla, Colombia, she began her career as an interior designer, pivoting to fashion in 1987 and opening her first boutique in Miami a decade later. By the time she expanded into wholesale in 2017, Tcherassi had an established bricks-and-mortar presence across South America, Spain and Miami. Her collections are now available on prominent online platforms like Moda Operandi and Net-a-Porter, elevating her brand's global reach. Tcherassi also extends her creative vision into hospitality by operating a hotel in Cartagena, named one of the best boutique hotels in the world by *Condé Nast Traveler*.

Designed in her atelier in Miami and produced in Colombia, her brand embodies Latin American sophistication and femininity, expressed through billowing sleeves, bias-cut dresses and an easy, graceful attention to fabric details, whether by layering floral appliqués over macramé or cinching a silk tunic with her signature knot. Another signature of the brand? The canvas-like quality of her designs. "I have never thought of creating a collection that is not somehow related to art," she once said, attributing much of her inspiration to art, music and literature. Her collections reference such artists as Damien Hirst, Mark Rothko and Cy Twombly, reinterpreted with a feminine point of view.

Over the years, her contributions to fashion have earned her numerous accolades, including the Officier de L'Ordre des

Miami Designers

Models pose backstage at the Silvia Tcherassi
Show during Miami Fashion Week 2016.

Arts et des Lettres from France, highlighting her significant
impact on the global fashion landscape. In 2003, she was the
first Latin American designer invited to Milan Fashion Week
by the Camera Nazionale della Moda Italiana, as well as to
Paris by the Fédération de la Haute Couture et de la Mode
the following year. In 2020, she welcomed her daughter, Sofia
Espinosa Tcherassi, as the director of ready-to-wear, ensuring
the brand's legacy continues while maintaining a modern
aesthetic rooted in their Colombian heritage.

Miami Designers

Miami-based designer Carolina Kleinman creates her collections in the communities that inspire them, partnering with local artisans to ensure their craft is honoured and profits return to their region.

Carolina K

For many fashion brands, sustainability is something they aim to incorporate; rarely is it an imperative. The opposite can be true for Carolina K, a bohemian brand known for blending sustainable fashion with artisan craftsmanship. It was founded by Carolina Kleinman in 2005, who drew on her family's deep roots in textiles from Bolivia and Argentina, as well as her world travels and time living abroad in Tepoztlán, Mexico.

Based in Miami, where the Argentinian designer now lives and works, Carolina collaborates with artisans from remote communities across Latin America and India, working year-round with cooperatives of over 300 artisans, ensuring her collections not only support local communities but also preserve ancestral craftsmanship that has been passed down through generations. "It would be easier to just get samples or inspiration and produce them elsewhere," Kleinman once told *Condé Nast Traveler*. "But I love the challenge of working directly with the artisans where the ideas originate. It's important to me to respect their culture and ensure the products are made where the inspiration came from."

Her designs, known for their bold prints, intricate weaving, billowing silhouettes and unique embellishments, offer a fresh, authentically bohemian take on luxury resortwear, ideal for women who seek versatile, statement pieces with a deeper cultural narrative. She prioritizes using natural and recycled fibres in place of traditional synthetics, as well as organic cotton and linen. Their zero-waste initiative ensures that every scrap of fabric is used, which is why swimwear is made from recycled water bottles and other forms of waste.

Miami Designers

CONTEMPORARY

JBQ

JBQ is a contemporary brand founded by mother-daughter duo Maria and Sydney Strauss, inspired by their Miami upbringing, beach-centric lifestyle and Caribbean heritage. The brand confirms the time-honoured adage that as a brand, you don't need to offer an extensive range of products; you just have to make a few very well. It began with a simple idea of turning a Turkish towel – often wrapped around the waist as a cover-up – into an actual skirt. This approach led to the creation of their linen Tulum skirt, which remains one of their bestsellers.

JBQ stands out for its dedication to sustainability, releasing the same iconic pieces season after season, as well as new styles in the same or complementary fabrics. This enables customers to build a capsule wardrobe, particularly those who live in warmer climates. "We want you to build upon our four pieces and continue to add because you know that the fit and quality are great. That's what a sustainable wardrobe is," says Sydney. A commitment to sustainability is a core metric of the brand, which emphasizes a zero-waste approach by sourcing Oeko-Tex certified materials and collaborating with suppliers to ensure ethical production practices while diverting waste from landfills. They also take pride in being able to support the South Florida fashion industry by designing and producing everything at their Miami headquarters, where they provide jobs for over 50 employees, mostly women.

Inspired by Turkish towels, the Tulum skirt remains one of JBQ's most iconic pieces.

Alexis

Few brands understand the sartorial needs of Miami's fashion set like Alexis, a line that balances a resort state of mind with cosmopolitan sensibility. Founded in 2009 by mother-daughter duo Ana and Alexis Barbara, the brand is a closet staple for many South Florida women, as well as those who live in or frequent warm-weathered locales. Alexis is devoutly feminine, known for well-constructed garments that can carry women from beach to brunch to dinner to special occasions, season after season. Designs subtly embrace trends while never veering from the brand's DNA, showcasing intricate lacework, trimmings and embellishments that catch the eye without being overwhelming.

For promotion, Alexis relies on a long list of influencers and celebrities who organically choose the line for everyday living, including the Kardashians, Beyoncé, Taylor Swift and Olivia Culpo.

Though Alexis Barbara cites travel as the main inspiration behind their collections, she emphasizes the significance of her hometown, once stating, "The vibrant colours, the culture, the feeling ... it's so important that our roots are in Miami."

Alexis is a brand well known by locals for its cosmopolitan take on resortwear.

STREETWEAR

Andrew

Andrew is a Miami-based skate brand founded by Nick Katz, Pres Rodriguez and Adrian Douzmanian, born out of a desire to bring Miami's raw and real local culture to the world. The brand is known for streetwear that captures the gritty nuances of Miami culture, particularly through their collaborations with hyper local entities – whether it's the city's most iconic Cuban restaurant, Versailles, or Slip-N-Slide Records, the label credited with popularizing Miami artists like Rick Ross, Trina and Trick Daddy.

Andrew offers a range of graphic merchandise, skateboards and apparel, with T-shirts often emblazoned with the brand logo reinterpreted by underground artists and creatives. One such treatment shot the brand to fame when it was worn by Zendaya for an entire episode of *Euphoria*.

Stray Rats

Stray Rats, founded in 2010 by Julian Consuegra in Miami, began as a hardcore punk-inspired clothing label. Drawing on Consuegra's background designing flyers for punk bands, Stray Rats gained notoriety for its striking graphics that merged punk and hip-hop culture, standing apart from other brands that appropriated these movements. They were frequently brought up on Hypebeast forums, which led to early support from Tyler, the Creator and his music collective, Odd Future. Organically, Stray Rats became a cult item in streetwear.

Tyler, the Creator is among Stray Rats' earliest supporters.

The brand's list of high-profile collaborations is extensive, starting with a successful sneaker partnership with New Balance in 2018. The reimagined NB990v3, featuring bold purple and green colourblocking, resonated with fans of sneakers from the early 2000s and became a highly sought-after release. Further collaborations followed, including projects with Vans, Carhartt WIP and fashion multi-hyphenate Ava Nirui on a series of fashion Rat Girl Barbies. Marc Jacobs has partnered with Stray Rats twice; first on a Year of the Rat collection, blending the brand's graphics with archival motifs from Jacobs' early 2000s Stinky Rat line. The second was for Jacobs' Gen Z focused sub-brand, Heaven, which also tapped in 90s metal band Deftones and starred Frank Ocean in promotional materials.

Stray Rats' aesthetic is shaped by a mixture of influences, from Consuegra's siblings to his upbringing, particularly his exposure to Miami's vibrant 90s club scene. Although grounded in the hardcore punk world, the brand frequently riffs on video games, comics and other subcultures. Known for its bold, hypergraphic T-shirts, hoodies and accessories, particularly its Rat Girl subseries, the brand has maintained a distinct identity in the streetwear space, with Consuegra describing his aesthetic as "refined adolescence by design".

Pervert

"Pervert was always a brand I actively hunted," wrote the late sneaker industry veteran Gary Warnett. "It seemed to have the hip-hop and rave crossovers, captured the acid jazz craze of the time and had skater appeal too." The brand is often hailed as one of the most influential early streetwear brands, and had fate taken a different turn, we might be hyping it up today as much as Stüssy and Supreme. It was founded by Don Busweiler, a skateboarder from New Jersey who had moved

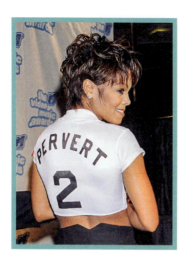

Janet Jackson wears a Pervert shirt to the 1995 MTV Video Music Awards. Shortly after, the brand's founder, Don Busweiler, disappeared.

to South Beach in 1989, a time when the island was hot and creative types were coming in droves. He borrowed $1,000 from a friend, produced a small run of T-shirts with the word *Pervert* on them and started peddling them along Ocean Drive for $15. He began sending free gear to rap groups like Cypress Hill and the Beastie Boys, which led to features in magazines like *Paper* and *The Source*. In the early years, you couldn't get anything unless you personally knew him.

Busweiler created Pervert as an outlet to challenge and reflect on the issues he observed in the world around him, but by the mid-90s, the hype surrounding it had come to represent all of the greed and commercialism he abhorred. In 1995, the same year Janet Jackson wore a Pervert T-shirt to the MTV Video Music Awards, Busweiler disappeared, selling all of his belongings to join a nomadic Christian cult. Though the brand no longer exists, its influence persists.

Miami Designers

chapter 4

STYLE ESSENTIALS

Ready to add a little Miami-ness to your wardrobe? "Miami style is all about keeping it sleek and sexy, with people showing a keen brand awareness and a love for designer shoes and bags," says Miami fashion expert and stylist Elysze Held. "While Palm Beach and Miami might rock the same dress, in Miami, it's definitely tighter and more body-conscious." We embrace individualism here, and the only rule is to wear whatever you choose with confidence. Here are some essential tips to infuse that Miami flair into your style.

COLOUR, COLOUR, AND MORE COLOUR

Colour is to Miami what black is to New York or Paris. Locals embrace bright colours and bold prints with unapologetic enthusiasm, whether opting for head-to-toe pastels or mixing in neon accents. While neons may ebb and flow in other places, they remain a staple here, never out of place. Pastels share this status, offering a refreshing softness that feels right year-round. Although we appreciate black, especially for nights out, colour is integral to our wardrobes. A stroll through Miami reveals that fun is the underlying theme of our style. There are no rigid rules – wear shorts in summer, rock white after Labor Day and revel in the freedom to express yourself through colour.

Style Essentials

Influencers Valentina Ferrer and Isabela Grutman attend a Ralph Lauren x *W Magazine* party during Art Basel.

SOMETHING SEXY

In Miami, the less you wear, the better you feel. This is one of the most body-conscious cities in the world, where curves are shown off and skin is king.

Cutouts, cleavage, tight pants and short dresses – it's all about playing up your assets. Think lightweight fabrics that hug in all the right places, showcasing options that celebrate the human form. For men, leaving that third or fourth shirt button undone is perfectly acceptable. Sexy isn't limited to what you wear out to dinner and clubs; everything gets the "Miami" treatment, from business attire to everyday staples. It's not about being the loudest outfit in the room (though that's welcome too); it's about infusing self-confidence into everything you wear, incorporating your body into your look.

Above: At the 2020 MTV Video Music Awards, Maluma debuted a neon suit from Balmain's upcoming collection, inspired by *Miami Vice*.

Opposite: Pop star and Miami-native Camila Cabello wears a body-conscious clubwear-inspired look to the F1 Miami Grand Prix.

A LiTTLE FLASH

This manifests in clothing choices, ranging from garments with a hint of sheen to full-on metallic ensembles, as well as in our accessories – think layered jewellery, fierce aviators, sky-high stilettos or the latest sneaker drop.

While any stone or metal will do, our unique affinity for gold shines through, especially in watches and the hip-hop favourite: Cuban links. Logos are layered on liberally,

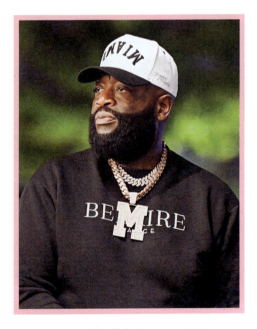

Rick Ross proudly reps Miami's flashy energy with his signature silk shirts, gold Cuban link chains and love for Maybachs, blending street culture with a Tony Montana-inspired aesthetic.

Michelle Pfeiffer's character Elvira in *Scarface* embodies 1980s glamour with sleek silhouettes, bold colours, and luxurious fabrics that mirror her icy confidence and the opulence of Miami's underworld.

showcasing our love for designer handbags, watches, belts and shoes without shame. Quiet luxury? Not for us. Subtlety isn't in our vocabulary; we prefer to flaunt our style loud and proud. Take Elvira from the movie *Scarface* – her style was marked by flowing silks, tailored suits and subtle metallic accents that whispered loudly. In this subtropical city, shamelessness becomes a strength, making even the simplest looks feel like power moves.

SWiMWEAR

No matter where you are in Florida, you're never more than 96km (60 miles) from the ocean, which makes swimwear basically utilitarian.

Of course, in Miami what's pragmatic is also posh, so expect bikinis to be more revealing, one-pieces to be more fashion-forward and men's swim trunks to be more fitted. Swimwear carries different levels of formality depending on the occasion. For a beach day and cookout with friends in Key Biscayne, a simple triangle top bikini paired with Havaianas is perfectly acceptable. However, if you're heading to a pool party in South Beach, you might want to opt for something more upscale – a sexy bikini made from luxurious fabric, complemented by a glamorous cover-up and stylish sandals or wedges for a day club vibe.

Above: Shot by Arthur Elgort for *Vogue* in 1989, Jenny Howarth shows how bold prints – from florals to polka dots – can come together for a playful, striking beach look.

Opposite: Miami continues to be a getaway for celebrities. Actress and entrepreneur Shay Mitchell on the beach in colourful swim and resortwear.

CITY RESORT

Cruise collections work year-round here, as temperatures rarely drop below 24°C (75°F). But it's not about dressing for an all-inclusive; instead, we infuse our looks with a cosmopolitan edge.

Lightweight linen and cotton are go-to fabrics. Men can effortlessly style oversized linen button-downs with tailored shorts or pants, while women embrace lightweight dresses and tunics. Cover-ups, like pareos, tunics or flowy robes, transition seamlessly from beach days to brunch without needing to change out of a swimsuit. A common misconception is that layering isn't feasible here, but it is. Accessorizing is key, whether it's with unique jewellery, stylish hats and designer handbags, making resort wear suitable for everything from casual outings to upscale events.

Style Essentials

Pharell has long had ties to Miami, most notably through fashion and hospitality projects. Here, he attends the Chanel Cruise 2022/23 show in South Beach in a matching Chanel set.

GUAYABERAS

The guayabera is a quintessential menswear button-down deeply rooted in Latin American and Caribbean culture, characterized by its boxy shape, four front pockets and vertical pleated stripes.

In Miami's Cuban and Latin American communities, it's appropriate attire for special occasions, business meetings, evening activities and even weddings if "guayabera formal" is the dress code. Although its exact origins are debated – claimed by Cuba, Spain, Mexico and the Philippines – historical evidence suggests it emerged in Cuba during the eighteenth century in the Sancti Spíritus Province, where inhabitants of its capital city along the Yayabo river are known as *yayaberos*. As a common story goes, a farmer asked his wife to make him a functional shirt to hold his belongings while working, so she made him a shirt with pockets wide enough to fit guava fruits. While its popularity waned in Cuba post-1959, it remains a popular clothing item in Miami, now being reimagined in different materials and for women and children too.

Style Essentials

In Miami's Cuban and Latin American communities, guayaberas are suitable for special occasions, even weddings if "guayabera formal" is requested.

chapter 5

VICE & VERSACE: MIAMI IN POP CULTURE

MIAMI VICE

Every melting pot has a boiling point, and Miami reached it in 1980. The city was no longer capturing headlines as a paradisiacal place to vacation or retire; it was the murder capital of America. Drug-fuelled violence, race riots and hundreds of thousands of refugees arriving all at once from Haiti and Cuba had tipped the scales of the city into chaos. It was a perfect storm – and one that happened to make for good TV.

The negative headlines may have deterred most Americans from visiting, but they caught the attention of Anthony Yerkovich, the creator of *Miami Vice*, and Michael Mann, the show's producer. Whereas Yerkovich was attracted to the complex criminal underbelly of the city, Mann had his sights set on Miami's aesthetic. He was enthralled by the art deco buildings in a crumbling and seedy South Beach, the pink flamingos that roamed Hialeah racetrack, the architecturally daring high-rises springing up along Biscayne Bay, the pastel-hued sunsets that lit up the city's periphery. In *Miami: City of the Future*, T.D. Allman quotes what Michael Mann said when asked what ultimately convinced him to bet it all on Miami: "That pink. That incredible Miami pink."

Before 1984, Miami had existed only as a place. But when *Miami Vice* premiered, Miami emerged as a style. The show's action-packed plots were coated in neon visuals, a soundtrack of synth pop and new wave hits, and a chic, Easter egg-hued wardrobe unlike anything the world had

From pastel suits to neon skylines, *Miami Vice* didn't just redefine menswear – it made Miami the epitome of 1980s glamour and edge.

Miami Vice transformed menswear, bringing designer clothing to the forefront and popularizing lightweight Italian tailoring and a modern, unstructured look that changed how American men dressed.

ever seen on television. It centred on two undercover detectives, James "Sonny" Crockett (played by Don Johnson) and Ricardo Tubbs (played by Philip Michael Thomas), as they navigated Miami's criminal underworld. Like any cop drama, each episode followed Crockett and Tubbs as they took on nefarious enterprises. But unlike any cop drama, this was Miami and the protagonist drove a Ferrari, owned a pet alligator and wore Versace suits. As former *GQ* editor Jim Moore noted to the *New York Times*, this was "the first point in fashion history where a TV show influenced fashion", making details like stubble, wrinkled trousers and casual Italian elegance mainstream.

Costume designer Jodie Lynn Tillen set the tone for *Miami Vice*'s first season, rejecting earth tones and traditional menswear in favour of pastels, Italian T-shirts and the unstructured jackets that gave the show its casual luxury aesthetic. Speaking to *The Hollywood Reporter*, Tillen agreed that people always assume the cast wore Armani, but pointed out, "there was not a piece of Armani in the entire [first season]". Instead, she embraced designers like Gianni Versace, favouring a more experimental, daring look. Each season, costume designers would travel to style capitals like New York, Paris and Milan to scour the latest collections, a standard practice today but unheard of at the time.

Bambi Breakstone, who took over from Tillen in Season Two, introduced oversized styles from European designers like Adolfo Domínguez and Cerruti. Don Johnson's wardrobe expanded with key pieces from Hugo Boss, Basile, Byblo and Giuliano Fujiwara, while Philip Michael Thomas' Tubbs character was given a more sharply tailored and deliberate look. Tubbs' style channelled his New York roots, with fitted double-breasted suits and accessories that included belts, socks and shoes – often from Hugo Boss, Cerruti and Gianni Versace – establishing him as the more conscious dresser.

Vice & Versace: Miami in Pop Culture

Armani wouldn't appear in the show until Season Three, when Oscar-winning costume designer Milena Canonero took over with Richard Shissler. They introduced a darker, moodier palette that reflected *Miami Vice*'s evolving, more complex storylines. "It's not so much that we've done a new look," she told *Vogue* in 1986. "We've updated it so things don't get stale." Canonero's influence added an air of sophistication, making way for sleeker, more refined silhouettes. The show's female characters were also some of the most fashionable of the time, sporting looks from Katharine Hamnett, Versace and Donna Karan. In its final season, the cast's style evolved to reflect the grittiness of 1989, incorporating stonewashed denim, leather jackets and vests into Sonny's wardrobe.

It was the show that spearheaded luxury branded deals. Onscreen, Breakstone used her industry connections to broker a partnership with Hugo Boss, securing a product-for-screen credit deal, which hadn't been done before. For Season Three's shifting storylines, Canadian New Wave label Parachute, worn by Madonna, David Bowie and Duran Duran, signed on, further cementing the show's edgy appeal.

Offscreen, brands like Kenneth Cole introduced "Crockett" and "Tubbs" shoes and Macy's dedicated an entire section to *Miami Vice* styles. A senior vice president at Bloomingdale's noted, "The show has taken Italian men's fashion and spread it to mass America."

While Sonny's pastel linen suits are synonymous with *Miami Vice*, it was Tubbs' sharp tailoring and New York-inspired looks that made him the show's more fashion-forward character.

MIAMI VICE'S INFLUENCE ON FASHION TODAY

It's impossible to downplay *Miami Vice*'s ongoing influence on fashion. The show's unmistakable aesthetic, from pastel-coloured suits to neon-soaked backdrops, has left a permanent mark on fashion mood boards, consistently influencing Spring/Summer collections over the past 40 years. It's also helped international designers get a sense of how the Western hemisphere perceives glamour and luxury. "The way we got to know America was through television," Italian designer Brunello Cucinelli once told *Women's Wear Daily*. "The imagery was *Dallas* and *Miami Vice*."

Balmain's 2021 collaboration with Maluma is a prime example, with creative director Olivier Rousteing drawing from the show's oversized silhouettes and neon colours. Designed amid the stay-at-home mandates of the Covid-19 pandemic, the collection featured bold, casual pieces like pin-striped blazers and T-shirts and hoodies with neon script. "I love obviously black-and-white stripes because it reminds me of that *Miami Vice* feeling," Rousteing told *Women's Wear Daily*, emphasizing the show's lasting impact on his designs. Similarly, Francesco Ragazzi of Palm Angels titled his Spring/Summer 2023 collection "Welcome to Miami", embracing the city's neon charm with kitschy beach shop T-shirts, Hawaiian shirts with shadowy palms and oversized double-

Former basketball player and fashion icon Dwyane Wade's pink double-breasted suit channels the timeless influence of *Miami Vice*.

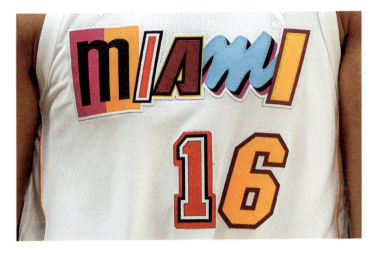

The Miami Heat's "Vice" uniforms, featuring bold
colours like laser fuchsia and blue gale, became
Nike's most successful City Edition release.

breasted suits in bold shades. Ragazzi's outsider, skate-luxe
aesthetic mingled seamlessly with *Miami Vice*'s brash pastels
and angular shapes, offering a modern, irreverent twist on
the iconic 1980s look. And who can forget Karl Lagerfeld's
"Miami Vice" pistol heels from his Chanel Cruise 2009
collection, which was shown on a runway built over the
Raleigh Hotel's iconic pool.

The general "powder suiting" trend that emerged in 2019
is rooted in the *Miami Vice* aesthetic, with everyone from
celebrities to politicians expanding their business repertoire
with sherbet-hued shades. Even if they don't directly
reference the show as an inspiration, disassociating it from
the collections of designers like Dries Van Noten, Gucci
and Tom Ford can sometimes be difficult. Dries Van Noten
has shown bold-coloured suits with loose, 1980s-inspired
silhouettes, while Tom Ford's menswear collections often

feature ultra-saturated tones that evoke the show's sun-drenched aesthetic. His Spring/Summer 2023 collection was resplendent with dusty pink layers, oversized aqua suiting and satin shirts unbuttoned practically to the waist.

The show is also an inspiration point for sports teams and sportswear brands, the Miami Heat's "Vice" City Edition uniforms being a standout example. Launched in collaboration with Nike, these jerseys captured the vibrant, retro aesthetic of the 1980s TV show and were the franchise's most successful jersey release. In its first year, the Vice jersey sold more City Edition versions than all the other 29 NBA teams combined, driven largely by its use of colours like "laser fuchsia" and "blue gale".

Miami Vice didn't just influence fashion – it rebranded an entire city and redefined the scope of what menswear could be. "Suddenly Miami wasn't just booming; it was fashionable. Wealthy Venezuelans, glitzy Europeans and Arab oil sheikhs flocked in," writes T.D. Allman in *Miami: City of the Future*. "Almost overnight the Miami look became the hottest thing in everything from rock videos to sports clothes. Miami had staked out a whole new niche for itself in the world's imagination." The show turned Miami from a beachy backdrop into a cultural icon, synonymous not just with neon-lit nights and pastel suits, but with grit and glamour, an alluring seediness draped in silk and sunshine.

"Today, the phrase "Miami Vice" is essentially an adjective, evoking a very specific aesthetic – bold, bright and unmistakably Miami.

THE BiRTH OF SoBe

While the public focused on *Miami Vice*, a creative undercurrent was quietly taking over Miami Beach. In the early 1980s, South Beach was the poorest neighbourhood per capita in the state of Florida. Its residents, mostly retired Eastern European Jews from New York, were beginning to age out of their golden years. Crime was up and the art deco buildings in which they lived had slid into decay. Despite this, a small artistic community, lured by cheap rents and the nostalgic character of art deco architecture, saw the area's potential and began to do what artists do: revitalize it.

The foundation was set by Barbara Baer Capitman, who founded the Miami Design Preservation League in 1976. She believed that preserving the unique art deco structures was not only an historic architectural imperative, but would also entice developers, cultural institutions and business owners to invest in and revitalize the area. She was right.

By 1986 it was in full swing. Nearly all 52 buildings along Ocean Drive had changed hands, their terraces transformed into chic European-style sidewalk cafés. Lincoln Road's storefronts, which had fallen into disrepair, blossomed into artist studios, multi-use galleries and quirky boutiques. Even the Miami City Ballet took up a set of storefronts; you could just as easily watch dancers rehearse Balanchine as window-shop for shoes. The scene was attracting rising names in the art world like Kenny Scharf and Keith Haring, who contributed public art pieces to the city.

South Beach's revival owes much to the Miami Design Preservation League and Leonard Horowitz, who crafted a pastel colour palette inspired by the island's sunrises and sunsets.

Above: In the 1980s and 90s, drag queens
ruled the night in South Beach.

Opposite: A wild party at Warsaw Ballroom
on Washington Avenue, South Beach.

Nightlife returned to the beach in the form of jazz clubs,
blues bars and nightclubs. Restaurants and bars became
cultural hubs, hosting everything from photo exhibits to open
mic nights, and from fashion shows to live performances by
icons like RuPaul, Grace Jones and Gloria Estefan. Venues
such as Club Nu, Vandome and Warsaw Ballroom emerged
as sanctuaries for flamboyant self-expression, where fashion
was daring, eclectic and unapologetically bold.

It cannot be understated how much the gay community
acted as a catalyst for the reinvention of South Beach. Drag
queens not only performed and hosted parties at many

venues around South Beach, but also ran the doors, setting the tone for the area's atmosphere. Sundays drew thousands to South Beach for the weekly tea dance, a lively street party that fostered a thriving LGBTQ+ community during a time of discrimination. Of all the movies set in Miami at the time, *The Birdcage* captures this era best, highlighting South Beach as a playground for fashion, freedom and cultural fluidity.

The beach became a melting pot of style tribes, featuring everything from muscle boys and models rollerblading in jean shorts and tank tops to drag queens who redefined high fashion with their creative takes on runway looks. Clubgoers often donned pieces by designers like Thierry Mugler, Jean Paul Gaultier, Versace and Patricia Field, but more frequently, they crafted their looks from vintage finds and quirky local boutiques. By day, the style was an eclectic mix of breezy, beachy outfits, while at night, the area transformed into a playground for club kids in rave attire, alongside a burgeoning hip-hop, skate and surf scene.

"It's such a change from neurosis and aggression to retirees and sunshine," said a New York artist to the *Miami Herald* in 1986. "It's so freewheeling. You get the feeling of being in an area that's on the verge of becoming." Promoters sold the island as a "Soho in the Sun". The artists called it "SoBe." Suddenly, the beach was young – and about to be filled with beautiful people.

Opposite: There was a sense of cultural freedom and fluidity in South Beach.

Overleaf: *The Birdcage*, starring Robin Williams and Nathan Lane, poignantly depicted the exuberance of gay culture in South Beach at that time, cementing it as a playground for fashion, freedom and cultural fluidity.

LIGHTS, CAMERAS, MODELS

"Three naked men, well oiled, draped themselves on the Breakwater Hotel sign Friday and hardly anyone noticed," read the opening line to a 1986 *Miami Herald* article. In the new bohemian spirit of South Beach, they could easily have been confused for freewheeling sunseekers looking to even out their tan. But a few months later, this gaggle of impeccably chiselled models appeared in some of the decade's most provocatively beautiful and enigmatic advertisements. The photographer? Bruce Weber. The product? Calvin Klein's Obsession.

While it wasn't Weber's first shoot in Miami, it marked the first time a major photographer showcased the creative possibilities of the city's once-overlooked art deco buildings, all bathed in the city's one unmistakable feature: that bright, mythical Miami light.

Almost overnight, Miami's modelling industry exploded. Photographers flocked to the city, lured not just by the winter sunshine and endless array of optimistic art deco backdrops, but also the unparalleled variety of scenes within a short distance. They could capture sleek cityscapes against the Brickell skyline, escape to nondescript beach stretches that could easily pass for Caribbean islands, or venture to the rural Redlands for idyllic farmland shots. Even the Everglades provided a swampy, otherworldly setting.

While high-profile editorials provided the buzz, it was the steady stream of catalogue work from Europe, particularly Germany, that formed the backbone of the industry.

Models Jenny Howarth and Carré Otis skip through South Beach for a *Vogue* editorial shoot by famed fashion photographer Arthur Elgort.

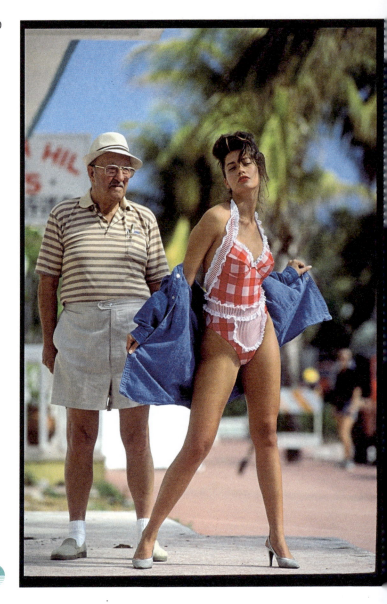

Between September and April, South Beach became the epicentre for photo shoots, with an entire ecosystem developing to meet every team's needs. Major modelling agencies like Ford, Michele Pommier and Irene Marie established branches in the area, discovering talents like Christy Turlington and Niki Taylor. Local production companies sprang up, handling everything from securing visas to renting yachts. Hotels outfitted themselves with rolling racks, dedicated wardrobe rooms and even film labs in their lobbies. Hairdressers, make-up artists, fitness trainers and caterers flocked to the area, finding ample work in this booming industry.

By the early 90s, 100 fashion crews could be shooting in Miami on any given day, with companies like Otto, the German catalogue giant credited with launching Miami's modelling boom, pouring up to $20,000 per day and staying for weeks at a time. At its peak in 1994, Dade County estimated that the modelling and fashion industry contributed $1 million a day into the local economy, making it the area's fifth largest economic driver when combined with film. The fashion industry alone accounted for 40 to 80 per cent of all hotel bookings around Ocean Drive. Local businesses began rolling out the red carpet for models to dine, drink, stay and shop at their establishments because, as it turns out, seating beautiful people at the window is good for business.

Opposite: Every winter, Miami turned into an outdoor studio for international catalogue shoots, drawing photographers with its warm weather, unique light, vibrant architecture and local charm.

Overleaf: An entire ecosystem sprang up to support the modelling industry, with local businesses coordinating everything from yachts to wardrobe rooms, while stylists, trainers and caterers flocked to South Beach.

Vice & Versace: Miami in Pop Culture

Vice & Versace: Miami in Pop Culture

THAT HOT, HOT MiAMi LOOK

Much as they had come in the pre- and postwar years, fashion editors, buyers, retail executives and creatives within the industry were spending weekends in South Beach. You could flip open any newspaper or magazine to find arbiters of taste singing Miami's praises. "It reminds me of Ibiza and St Tropez," said Gerard Pippart of Nina Ricci. "Now it's suddenly younger, with very attractive people wanting to be there," echoed Chanel CEO Arie Kopelman. The city's optimism was palpable – its pastel art deco buildings, sun-soaked beaches and buzzing nightlife embodied the free-spirited, youthful vibe that designers and tastemakers craved with the 90s in tow.

In 1989, *Vogue* published not one but two multi-page fashion editorials set in South Beach. Arthur Elgort captured Carré Otis and Jeny Howorth frolicking on the sand in bright abstract prints by designers like Byblos, Escada and Moschino, changing into more minimal looks for the evening like a sheer, deep-V dress by Azzedine Alaïa, white silk pyjamas by Norma Kamali and a classic black Michael Kors mini – no shoes needed. In Bruce Weber's "Mucho Mas", actress and model Talisa Soto and a jiu-jitsu star moonlight as lovers, making out in his pool, eating Cuban food in an eclectic beach apartment and wearing little more than "that hot, hot Miami look: wet hair, a tan".

Marc Jacobs was so enamoured by South Beach in the 1980s, it inspired an entire spring collection with sequinned "towel dresses" showcasing iconic resort logos.

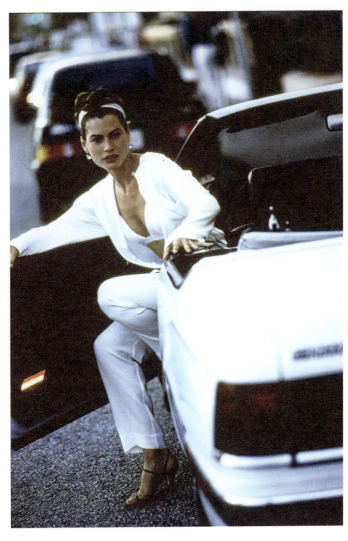

Carré Otis in a white silk pyjama set by Norma Kamali, captured
by Arthur Elgort for *Vogue* in 1989 – embodying South Beach's
exuberant, free and unapologetically sexy style heading into the 90s.

The fashion industry propelled Miami's image
of a glamorous, trendy destination.

Vice & Versace: Miami in Pop Culture

Miami has long sparked a dreamlike vision for fashion
designers and stylists, more a reflection of their imagination
than the actual style of the city's residents. Right before
taking the reins at Perry Ellis, Marc Jacobs released an entire
collection inspired by South Beach and Miami's Cuban
culture. His Spring/Summer 1989 collection featured voile
guayabera button-downs, oversized blazers paired with
capris and Panama hats and sequinned silk "towel dresses"
embellished with Florida resort logos from the Eden Roc and
Breakers. The show was so Miami, even the palm trees were
sent from the Fontainebleau.

But designers weren't just looking to Miami for inspiration; they were seeing it as a viable place to do business and live. Amid the local shops selling everything from Victorian recreations to "showgirl couture", you could now find Seventh Avenue designers like Betsey Johnson, Cynthia Rowley, Nicole Miller and Todd Oldham in South Beach. Luxury boutiques and brands like Versace Jeans and Armani Exchange moved in as well. Bruce Weber, Patricia Field and Barbara Hulanicki were among the first tastemakers in that generation to embrace Miami Beach as a home. They still live here today.

What had once been a sleepy beach town now pulsed with fashion crews, models and artists, all of whom fuelled Miami's fashion industry, injecting millions of dollars into the local economy and reinventing its image for the modern world as much as *Miami Vice* did. This was the birth of SoBe – the unhinged nightlife, the optimistic energy, the vibrant gay community, the style – so sexy and free. The foundations were already prepared, so that by the time Gianni Versace arrived in South Beach, all he had to do was pour the cement.

Todd Oldham was among many New York designers who not only opened up boutiques around Ocean Drive, but helped design clubs, bars and hotels.

VERSACE'S MiAMi

Gianni Versace's initial visit to Miami didn't leave a good impression. "The first time, about ten years ago, I hate Miami," he told the *Miami Herald* in 1993. "I stay two days, and fly away." Having created the *Miami Vice* look, Versace was no stranger to the city; he did enough business here to warrant a three-storey expansion of his store at Bal Harbour Shops.

In 1991, he was on his way to Cuba with his partner Antonio D'Amico when, at the urging of his sister, Donatella, they decided to drop in for a night and give the city another chance. He asked his driver to show them "something fancy and fun about Miami", so the driver took them to South Beach. Sitting there at the News Cafe, Gianni turned over to Antonio and asked, "Why we not stay here and not go to Cuba?" As he would often say, "It was love at first sight."

From that moment on, Miami became his muse. Gianni may have brought his powerhouse glamour to South Beach, but that's not what attracted him to the city. "It's like the fifties in Capri," he confessed to *Vogue*. "Everything is fresh, and the attitude is beautiful. You don't need to go to the cinema. You just watch the people and it is like taking pictures, and everyone is equal. You don't need to be rich to be special. It's real freedom."

Within a year, he had found himself a place, Casa Casuarina – an historic but dilapidated Mediterranean revival-style apartment building on Ocean Drive. He bought the hotel

Vice & Versace: Miami in Pop Culture

To Versace, South Beach was more than a home – it was a muse, inspiring his collections throughout the 90s and serving as his sanctuary.

next door, razed it and began an extensive renovation that would infuse all the Greco-Roman grandeur and excess that Versace was known for into his brand-new villa. He preserved a number of original elements of the home, including its name, and filled the interiors with new arresting features like ombre stained-glass windows, frescoed walls and ceilings and globally sourced furniture all reupholstered with Versace fabrics. On the site of the former hotel, he built a guest house and the new focal point of the estate: a lavish pool and courtyard inlaid with thousands of 24-carat gold tiles imported from Italy, some arranged to form a large-scale Medusa, others to replicate one of his silk prints in the pool.

"Versace had a voracious appetite for knowledge, and when he learned something, he shared it with his audience through his work," wrote the *New York Times* in his obituary. And so,

At Casa Casuarina, Versace combined preservation with opulence,
introducing frescoed walls, ombre stained-glass windows
and furniture reupholstered in signature Versace fabrics.

he shared Miami with the world. The beach's influence began
to seep into his collections almost as soon as his feet hit the
sand. While his Spring/Summer 1992 collection is replete
with seashells and coral printed on silk or worn as maximalist
necklaces and belts, his 1993 men's and women's ready-to-
wear collections are total homages to Miami and the free-
spirited ease he felt there. Necklines were busty, shorts were
brief and fabrics flowed freely – just the attire you'd want for
sunny days and balmy nights on the beach. There were nods
to Latin culture, with skirts, pants and sleeves that flared out
like conga wear. What really marked this collection, though,

was Versace's generous selection of silk button-down shirts chock-full of references to Miami: palm trees, Cadillacs, the Fontainebleau's grandeur and Spanish galleons (a presumed reference to Casa Casuarina). These shirts, unbuttoned to the waist on men and tied as crop tops in the front for women, would become a Versace signature for years to come. The rest of the world may have called his designs vulgar, but those deep V cuts and body-hugging fabrics were perfect for Miami's hot and flashy aesthetic.

Nowhere was Gianni and Donatella's infatuation with Miami more evident than in *South Beach Stories*, a 244-page coffee table book featuring a poetic tale by Marco Parma. Shot by Doug Ordway, the book showcases striking images of brooding musclemen appearing in various Miami locales – from wearing head-to-toe leather biker gear on Key Biscayne to commanding killer whales at the Miami Seaquarium. Some of the most arresting shots highlight the uninhibited joy of South Beach at the time, whether it's Christy Turlington and Kate Moss skating down Ocean Drive in red bell-bottomed jumpsuits or a dozen men roaming the streets in the unbuttoned silk shirts.

Gianni's time in Miami is one of the defining pillars of both his life and the future of his fashion house. Donatella drew inspiration from Spring/Summer 1993 for her Spring/Summer 2006 collection, incorporating his signature rococo silk shirts in sun-bleached art deco tones, along with jacket sleeves pushed up just like the *Miami Vice* days. Versace didn't just share Miami with the world; he wove its essence into the fabric of his fashion legacy, making the city an indelible part of his story.

Versace's Spring/Summer 1993 collection paid homage to South Beach with flowing fabrics, vibrant prints and silk shirts featuring palm trees and Cadillacs.

Opposite and above: Versace's time in Miami introduced a new
era in his designs, defined by fluorescent tones, eclectic prints
and a bold confidence inspired by the city's unique energy.

Madonna was a celebrity fixture in Miami, often seen out and about with her friend, Liquid nighclub owner Ingrid Casares.

THE CELEBRITIZATION OF MIAMI

If the 80s in South Beach felt like tropical bohemia, the 90s were an all-out celebrity bacchanal. With Versace's stamp of approval, stars like Madonna, Sylvester Stallone, Oprah, Paloma Picasso and Cher began moving in, joining long-time residents like Julio Iglesias and Gloria and Emilio Estefan. Prince opened a mega club called Glam Slam. Sean Penn opened a lounge called Bang.

"South Beach, city of vampires, is the perfect playground for anyone who wants to forget the worries of a day (or lifetime), possibly reinvent themselves or be part of one of the most creative if hedonistic scenes anywhere in the world," wrote Tara Solomon, a South Beach fixture with her "Queen of the Night" column in the *Miami Herald*. The city offered an ideal escape from the public eye before the era of social media, allowing stars to party, relax and cut loose without constant paparazzi scrutiny, making their time here feel almost mythical. There was Kate Moss and Christy Turlington hanging out at biker bars with Marc Jacobs, Sting sipping cappuccinos on Ocean Drive, Elton John buying sparkly mules at a local boutique and the legendary promoter Susanne Bartsch doing any number of stunts, like flying in over a dozen drag queens in tango gear from New York. Madonna's comings and goings were painstakingly detailed and gossiped about: Madonna jogging at 4 a.m. Madonna renting out an entire spa for pals Rosie O'Donnell and Donatella Versace. Madonna eating a pitta on Española Way. Madonna at a strip club in north Miami-Dade. Much of her groundbreaking and racy book *Sex* was shot in Miami; some pictures were even shot in public.

Vice & Versace: Miami in Pop Culture

By 1995, South Beach had entered a new era of glitz and glamour, where images of wild nights out and celebrities in the sun replaced the previous era's association with crime and *Miami Vice*.

New clubs like Risk and Liquid were redefining nightlife, implementing stricter door and dress codes where sexiness, confidence and who you knew were prerequisites. As 90s minimalism took hold, clubwear shifted from eclectic and glamorous to sleek, sexy, metallic and black. Body-conscious looks dominated the scene in the form of skintight Lycra dresses and miniskirts paired with tanks and midriff-baring crops. The boutique art deco hotels were taking a backseat to splashy new openings like The Raleigh and Ian Schrager's Delano. South Beach was on display not just to the fashion set, but to the world via a string of films like *Ace Ventura: Pet Detective*, *Bad Boys* and *There's Something About Mary*. Will Smith assumed an ambassadorial role, minting the city's new theme song, 'Miami'.

DEATH OF BOHEMIA

On 15 July 1997, Gianni Versace was shot dead on the doorstep of his home. The fashion world mourned, and the age of innocence in South Beach was over. Sylvester Stallone and Madonna moved out.

European editors and photographers moved on, pummelling the city's modelling industry. Rents spiked, and by the mid-2000s, the only businesses that could afford to be on the beach were chain stores, restaurants and tourist shops. The atmosphere on the beach shifted, becoming more cautious and exclusive. There was no middle ground. It was either glamorous and guarded, or touristy and cheesy. Today, most traces of the South Beach bohemia have been washed away, but much of the legend developed in the 80s and 90s continues to capture imaginations worldwide.

AS NASTY AS THEY WANNA BE

Miami's style is a tale of two cities divided by a narrow bay: the neon-lit, glamorous South Beach of *Miami Vice* fame and the authentic pulse of the "real" Miami. It's a mix of glamour and grit, where fashion is always bold, at times abrasive, and always unapologetically in-your-face. The city's aesthetic blends Latin, Caribbean and streetwear influences, resulting in a visual language of oversized hoop earrings, gold chains, acrylic nails, neon shades and barely-there clothing. It's loud. It's gaudy. It's so Miami.

Miami bass, or booty music, was a game-changer in hip hop, emerging from Miami's streets in the 80s and 90s. Known for its heavy basslines and raunchy lyrics, it pushed boundaries, both musically and culturally. 2 Live Crew led the change, their explicit tracks resulting in a landmark Supreme Court case that solidified free speech in hip hop. The group made University of Miami jackets, flat-brim caps and gold rope chains their signature. UM football was dominating the national scene and 2 Live Crew's style became a powerful statement of hometown pride and Miami's untouchable, rebellious streak.

Miami rappers Trick Daddy and Trina later amplified this energy, with Trick's streetwear aesthetic of baggy jeans and grills, and Trina's flashy, skin-tight clubwear, neon accents and sparkling attire as the "Baddest Bitch", putting South Florida's unabashed style on a national stage. In the 2000s, Rick Ross continued this tradition, blending street culture with a Tony Montana-inspired aesthetic that epitomized Miami's luxurious side. He's known for silk shirts, fur coats

Miami hip-hop legends like Uncle Luke, Trick Daddy, and Rick Ross have shaped not just music but fashion.

and custom suits, paired with oversized aviators and gold Cuban link chains. Ross's association with cigars and luxury cars, particularly the Maybach brand, highlights Miami's fusion of power, style and excess, reflecting its continuous reinvention and in-your-face identity. At the same time, Pitbull was pushing a sort of "papi" look, with slim fitted shirts, high-waisted pants and his signature aviator shades.

Cuban links, a central element of hip hop jewellery, are a nod to Miami's Latin influence and have become a status symbol within the culture. It's hard to pinpoint their specific origins, but subtle versions have traditionally been worn by working-class Cuban men in Miami for decades. They began growing in popularity – and size – in the mid-2000s. Today, nearly every rapper and reggaeton artist has donned a version of these thick, rounded gold chains, encrusting them with diamonds or hanging massive pendants from the end.

2 Live Crew on the set of their video for 'Shake A Lil' Somethin'' in Liberty City, 1996.

Vice & Versace: Miami in Pop Culture

CHONGA STYLE

The chonga style, a distinct aspect of Miami fashion, is embraced by working-class Latina women, particularly those of Cuban, Puerto Rican and Dominican backgrounds. It's a strong, proud expression of identity, blending streetwear with hyper-feminine touches. The chonga look typically includes thick, perfectly drawn eyebrows, slicked-back hair with gel and dark lip liner. Signature clothing elements include tight, low-rise jeans, baby tees, skin-tight jersey dresses, nameplate necklaces and oversized hoop earrings, often paired with flashy acrylic nails.

"If I considered myself a feminist, it would be critical to understand the chonga, or Bratz, Miami aesthetic as an expression of resistance to US assimilation and respectability politics," writes author and professor Jillian Hernandez. "Our styles are often read in the U.S. as tacky, over the top, and deviant, even as they are simultaneously spectacularized, desired and appropriated."

This style gained prominence through the "Chongalicious" video by Miami natives Mimi Davila and Laura Di Lorenzo, which humorously showcased its unique traits while underscoring its role as a symbol of ethnic identity and rebellion. Miami rapper La Goony Chonga further amplifies this look through her music and Instagram series, "Chongafied", transforming individuals, including pop star Rosalía, into chongas. These transformations highlight the style's bold and confident essence, while its evolving subcategories, like "goth chonga" and "dominatrix chonga", draw on the Y2K fashion revival to reaffirm Latin identity.

Embracing her Miami upbringing, La Goony Chonga incorporates the Chonga aesthetic into her music and public persona, celebrating her cultural heritage and challenging stereotypes associated with Latina women.

chapter 6

THE STYLE
CAPiTAL OF
THE TROPiCS

Miami is always hot, but it's particularly hot *right now*. Style permeates nearly every aspect of life in Miami, going so far as to shape the city's cultural events and even real estate. Major events like Art Basel and Miami Swim Week showcase not only the latest trends but also the unique aesthetic that defines the region.

Miami has become a sought-after destination for some of the world's most influential fashion houses, serving as a stage for anticipated collections. Case in point: Dior's Pre-Fall 2020 menswear show, which resurrected streetwear icon Shawn Stussy to blend surf-inspired fashion with the city's unique architectural charm.

Chanel made waves by returning to the city after 14 years with its Cruise 2022/23 show. Set on the beach against a backdrop of red-and-white cabanas, the show reimagined coastal sophistication with classic Chanel tweed and plenty of motorcore references ahead of the inaugural Miami Grand Prix. Similarly, Hugo Boss's Spring/Summer 2023 ready-to-wear collection embraced Miami's legacy in pop culture, tapping into the city's *Miami Vice* roots with nostalgic loose tailoring, but also adding unexpected twists like transparency, cutouts and business formal accessories such as cufflinks and ties. The model call sheet included Pamela Anderson, Law Roach, Naomi Campbell and DJ Khaled, all walking along the former grounds of the *Miami Herald* offices. These moments underscore Miami's resurgence as a muse in the global fashion landscape.

DJ Khaled and Naomi Campbell on the runway of Hugo Boss's Spring/Summer 2023 RTW show in Miami.

FASHiON-FOCUSED EVENTS

Art Basel

New York has the first Monday in May. Miami has the first week of December. Art Basel, and the satellite art fairs, exhibitions and parties that collectively make up Miami Art Week, draws all eyes on the city as artists, collectors, celebrities and influencers come to engage with the latest trends in contemporary art and culture. Fashion finds its way into every corner, whether it's the fabulous and eye-popping street style or the plethora of fashion brand activity designed to capitalize on the cultural momentum.

Fashion has been finding its way into Miami's art scene since well before Basel in Miami was even a thought. In 1983, two artists wrapped 11 man-made islands on Biscayne Bay in Frangipani-pink polypropylene. *Surrounded Islands*, by Christo and Jeanne-Claude, was an international sensation, credited with establishing Miami as a contemporary art city. A little-known detail is that Willi Smith, credited by many as the father of streetwear, produced the uniforms for the hundreds of workers who rode boats out into the bay to make it happen. It was the first time a contemporary artist collaborated with a fashion label on industrially produced clothing, something commonly seen today.

Today, brands aren't so subtle. Recent Miami Art Weeks have showcased Louis Vuitton's beautiful tribute to the late Virgil Abloh, exhibiting his final collection for the brand at the abandoned Miami Marine Stadium under a drone-filled sky spelling: "Virgil Was Here". Chanel celebrated the

During Miami Art Week, street style takes centre stage,
blending artistic expressions with high fashion as the city
becomes a hub for creativity and cultural momentum.

centenary of N°5 and the opening of a new Miami flagship by commissioning a massive multistorey labyrinth by Es Devlin, where Rosalía performed to an exclusive crowd that included Pharrell, Joe Jonas and Venus Williams. At Design Miami, artist Harry Nuriev collaborated with Balenciaga to create a very Instagrammable couch stuffed with unsellable garments. Marni, Tiffany & Co., Fendi, Bottega Veneta – all have taken part in Miami Art Week. In fact, the list of fashion brands who *haven't* participated is likely shorter than the list of those that have, making the week as much a moment for fashion as it is one for art.

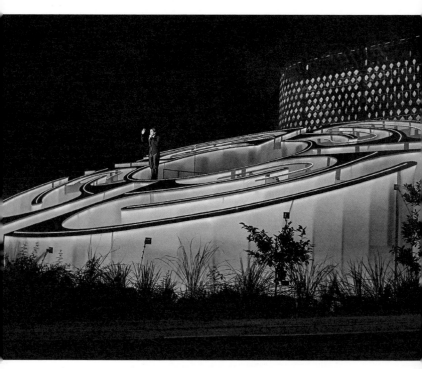

Rosalía performs atop "Five Echoes", an installation by Es Devlin for Chanel during Art Basel 2021.

Lewis Hamilton sports a custom made look by Marni at the 2024 F1 Miami Grand Prix.

Formula 1 Miami Grand Prix

The Miami Grand Prix has quickly become a standout event on the Formula 1 calendar. If Monaco is about history and Austin is for motorheads, Miami's event focuses on culture, blending high-speed racing with a fashion-forward atmosphere that sets it apart from other races. Since its debut in 2022, the Miami GP has set a record for Formula 1's US television audience: the 2024 race drew 3.1 million viewers. On the ground, the race draws A-list celebrities like Tom Cruise, Shakira and Kendall Jenner, who are often spotted wearing the latest designer fashions while mingling in the paddock and attending pre- and post-race activities.

The Style Capital of the Tropics

Miami Swim Week

Where better to host the swimwear industry's top event than in a city where the temperature rarely dips below 24°C (75°F)? Miami Swim Week is the fashion world's premiere swimwear showcase, highlighting the latest trends in swim- and resort wear.

Unlike more formal fashion weeks, Swim Week is known for its laid-back atmosphere, emphasizing lifestyle just as much as fashion. Business happens at the trade shows during the day, but evenings are filled with runway shows and events that perfectly match the Miami Beach vibe, making it easy to shift from work to leisure. This balance makes Miami Swim Week a welcoming space for new designers and a must-attend for top-tier swimwear brands.

Miami Fashion Week

Miami Fashion Week (MIAFW) is the only other American fashion week recognized by the Council of Fashion Designers of America (CFDA), differentiated by a strong focus on emerging and established designers from Latin America and Europe. Designers like Angel Sanchez, Agatha Ruiz de la Prada and Rene Ruiz are regulars, while recent headliners have included streetwear icon Karl Kani as well as Missoni. The event showcases a diverse range of fashion, including womenswear, menswear, resort and accessories, drawing an international crowd of media, buyers and fashion enthusiasts.

The Style Capital of the Tropics

Swim Week officially began in 2004 when IMG, operators of New York Fashion Week, launched Mercedes-Benz Fashion Week Swim. When they withdrew in 2015, events like Paraiso Miami Beach, Art Hearts Fashion, and Miami Swim Week The Shows took over, providing a platform for both emerging swimwear designers and well-established brands.

Latin American Fashion Summit

The Latin American Fashion Summit (LAFS) is a global platform founded in 2018 by Latina entrepreneurs Estefanía Lacayo and Samantha Tams with the goal of amplifying and advancing Latin American fashion and design, making them more prominent on the global stage. Bringing together designers, industry leaders and key players from across the globe, the summit includes conferences, networking events and pop-up showcases to connect Latin American brands with prominent international buyers and consumers.

In 2022, LAFS moved its flagship November event to Miami, which speaks volumes about the city's positioning as a cultural connection point between all of the Americas. "We really wanted to create this opportunity and visibility for all the Latinos living in the United States," Tams told *Women's Wear Daily*. "For us, it is really important – Miami because, first of all, it's like a melting pot of Latin culture in the United States."

Stitch Lab

Stitch Lab serves as a platform for Latin American fashion brands, offering a unique opportunity for consumers to discover emerging talent. Unlike the industry-focused Latin American Fashion Summit, Stitch Lab prioritizes engaging the Miami shopping community, hosting events that showcase innovative designers and their collections. By bridging the gap between designers and consumers, Stitch Lab enhances the visibility of Latin American fashion in Miami's dynamic landscape.

Kika Vargas attends the 2022 Latin American Fashion Summit in Miami, where she first gained recognition by winning the 'Pitch to LAFS' competition, a milestone that helped propel her career.

The Style Capital of the Tropics

SHOPPING

Miami is as much a destination for shopping as it is for vacationing, unique in its offering of outdoor malls and shopping districts, specialty stores, luxury brands and year-round pop-up markets. There are more shopping malls per capita in Florida than anywhere else in America, some of which have made both history and a splash in the global retail landscape.

Lincoln Road

Lincoln Road was conceived by Carl Fisher and marketed by the city as the "Fifth Avenue of the South". In the 1940s, stores like Bonwit Teller, Saks Fifth Avenue and Burdines lined the street, but by the late 1950s, Lincoln Road faced significant decline. To revitalize the area, city leaders brought in architect Morris Lapidus, who transformed it into one of the first pedestrian malls in the country in 1960, incorporating whimsical designs and lush landscaping. In the 1980s, Lincoln Road saw a resurgence as artists began occupying vacant storefronts, leading to a vibrant arts scene. Today, however, rising rents have resulted in a predominance of chain stores, overshadowing its original character. Looking ahead, plans are in place to enhance the cultural offerings and public spaces on Lincoln Road, potentially restoring its unique charm.

Bal Harbour Shops

Before 1965, luxury malls exclusively for elite clientele were unheard of, but Bal Harbour Shops changed retail history. Visionary Stanley Whitman faced scepticism for proposing a mall devoid of grocery and chain stores. The architecture was equally daring, as no one had built a three-storey, open-air shopping mall with koi ponds and tropical foliage flowing through it. Located on a triangular plot just steps from the beach, "Whitman's Folly" eventually became the highest-grossing mall in America per square foot, home to renowned brands like Chanel, Dolce & Gabbana and Balenciaga. Notably, it was home to the first Neiman Marcus store outside Texas, which opened in 1971, followed by Saks Fifth Avenue in 1976, which had never before considered opening up in a mall-like setting. This made Bal Harbour the first shopping centre in the world to house both retailers under one roof, setting yet another benchmark in luxury retailing.

Miami Design District

There's always something new to discover in the Miami Design District, a dynamic neighbourhood that is as much about luxury retail as it is architecture and art. What was once a sequence of blocks with interior design stores is now a thriving hub for some of the world's most prestigious brands, complete with Michelin-starred restaurants, galleries and an art museum. Each retail space is designed to reflect the unique brand it houses, creating a visually striking streetscape enhanced by public art on display. Beyond shopping, the Design District is a cultural hotspot that frequently hosts events and exhibitions, drawing art enthusiasts and the fashion community together.

The Style Capital of the Tropics

Vintage Stores and Flea Markets

Miami is witnessing a revival of vintage and thrift shopping, largely driven by millennial and Gen Z entrepreneurs who embrace sustainability and seek unique fashion finds. Stores like Mids Market Vintage & Thrift, Peachtree Revival and the long-standing Fly Boutique make second-hand shopping both accessible and enjoyable, offering affordable treasures like vintage denim and Y2K styles. Pop-up markets around the city, like Magic City Flea and Little River Flea, feature a variety of vendors selling vintage clothing, accessories and handcrafted items, all accompanied by live DJs and local food vendors, pushing the city to have a more eclectic fashion scene driven by personal style.

Concept Shops and Boutiques

The Webster, an iconic destination, is celebrated for its meticulously curated selection of high-end fashion and exclusive collaborations that showcase Miami's unique aesthetic. Originally a catalyst for revitalizing South Beach, The Webster now operates globally while maintaining its Miami soul. Stores like Curio, Simonett, Alchemist and Base embody the edgy, independent spirit of Miami, blending modern street style with artistic influences. Miami's streetwear and sneaker boutiques, such as Shoe Gallery, Unknwn and Kith, offer a curated selection. As more indie shops continue to emerge in neighbourhoods like Coconut Grove and Wynwood, Miami's shopping scene becomes an exciting tapestry of creativity and quality.

DESIGNER REAL ESTATE

Style is such a part of Miami that even the buildings are getting the designer treatment. Fashion-branded residences like the 57-storey Missoni Baia Tower and the apartment complexes Diesel Wynwood and Fendi Château Residences reflect the city's love for bold aesthetics and high-end luxury. Miami is known for being flashy and brand-centric, and now that mindset is extending to real estate, where lifestyle and fashion converge. These branded buildings offer more than just a place to live – they embody the spirit of luxury fashion, with sleek interiors, curated designs and unique touches that mirror the aesthetics of their respective brands.

This trend ties into Miami's overall embrace of the fashion lifestyle. The city's international appeal, energetic atmosphere and strong ties to Latin American and European fashion markets make it a natural fit for fashion-branded developments. These residences offer exclusivity and status, appealing to buyers who are not just seeking luxury but want to make a statement through their living spaces. For developers, aligning with prestigious fashion names offers a way to stand out in Miami's competitive real estate scene, while for the city, these projects continue to elevate its profile as a luxury destination.

The Style Capital of the Tropics

Above: Miami's stunning pink sunsets
have inspired everything from from fashion
collections to TV shows like *Miami Vice*.

Miami's fashion scene is a vivid reflection of its eclectic
identity, where bold colours and daring silhouettes thrive
under the sun. Infused with the rhythm and celebration
of Latin American influences, and shaped by iconic pop
culture moments like *Miami Vice* and the opulence of
Versace, the city weaves a unique narrative in style.

Overleaf: Ready for some fun?
Miami is always a good idea.

With a long history as a test market for summer trends, Miami has always been a soothsayer of sorts for fashion. Today, as initiatives foster local talent, the city is poised for a future that promises a rich tapestry of styles, making it an exciting place for designers and fashion enthusiasts alike.

Alaïa, Azzedine 114
Alexis 68, *68*
Alix of Miami 36, *39*, *40*
Allapattah 43
Allman, T.D. 90, *99*
Andrew 70
Armani 93, 95, 118,
Art Basel 6, 11, 13, *76*, 140,
 142–4, *141*, *143*
art deco 6, *9*, 13, 20, 90, 100,
 108, 114, 124, 131

Bal Harbour Shops 29,
 120, 151
Balenciaga 151
Balmain 6, 37, *79*, 96
Barbara, Alexis and Ana 68
Bartsch, Suzanne 129
Baykam, Hakan 47
Birdcage, The 52, 104, *104*
Blass, Bill 25
Bloomingdale's 95
Boss, Hugo 93, 95, 140
Breakstone, Bambi 93, 95
Breakwater Hotel 108
Brickell 16, 108,
Brother Marquis 135
Burdines 26, 28, 29, 30–33,
 31, *33*, 37, 150
Busweiler, Don 72–3, *73*
Byblos 93, 114

Cabello, Camila *79*
Campbell, Naomi 140, *140*
Canonero, Milena 95
Capitman, Barbara Baer 100
Caribbean *9*, 10, 66, 86,
 108, 132
Casares, Ingrid *128*
Chanel 114, 140, 142–4,
 144, 151
Chanel Cruise 84
Chonga, La Goony 136, *137*
Christo 142

Clemente, Dr Deirdre 20
Cohen, Sigal 42
Condé Nast Traveler 62, *65*
Consuegra, Julian 70, *72*
Cortázar, Esteban 52–5, *52*
Cover Girl of Miami 36
Crockett, James "Sonny"
 93, *95*, *95*
Cruise, Tom 145
Cucinelli, Brunello 96

D'Amico, Antonio 120
Dacron 42, *43*
Design and Architecture
 Senior High School
 (DASH) 48
Design Miami 144
Devlin, Es 144, *144*
Di Lorenzo, Laura 136
Dominguez, Adolfo 93
Donde Esteban 55
Douzmanian, Adrian 70

Elgort, Arthur *109*, 114, *116*
éliou 58–60, *58*, *60*
Elvira 81, *81*
Espinosa Tcherassi, Sofia 63
Euphoria 70

Fairchild, L.W. 37
Fashion Future Heritage 143
Ferrer, Valentina *76*
Field, Patricia 104, 118
Fisher, Carl 150
Flagler, Henry 16
Fontainebleau *39*, 117, 124
Ford, Tom 98, *99*
Freeman-Parker, Martu
 E. 48

Gaultier, Jean Paul 104
Glam Slam 129,
Graham, Karen 25
Grutman, Isabela *76*

GSaints 146
guayabera formal 86, *86*
Gucci 98

Hamilton, Sir Lewis 145
Hamnett, Katharine 95
Haring, Keith 100
Held, Elysze 76
Hernandez, Jillian 136
Hernandez, Lazaro 52,
 56–7, *57*
Horowitz, Leonard *101*
Howarth, Jenny 83, *109*, 114
Hulanicki, Barbara 118

Istituto Marangoni 47, *47*

Jackson, Janet 73, *73*
Jacobs, Marc 6, *72*, 114,
 117, 129
JBQ 66, *66*
JCPenney 37
Jeanne-Claude 142
Johnson, Betsey 118
Johnson, Don 6, *7*, 93
Jones, Grace 102

K, Carolina 65
Kamali, Norma 114, *116*
Kani, Karl 146
Katz, Nick 70
Key West 43
Khan, Naeem 48, *48*
Kleinman, Carolina 64, *65*
Kopelman, Arie 114
Kors, Michael 56, 114
KRELwear 42

Lacayo, Estefania 148
Lane, Nathan *104*
Lapidus, Morris *39*, 150
Latin American Fashion
 Summit 148, *149*
Levy, Karelle 42

LGBTQ+ community
 102–104
Liberty City 135
Lilly Pulitzer 36, 43
Liquid 128, 131
Little River Flea 152

Macy's 26, 32, 33, 95
Madonna 95, 128, 129, 131
Maluma 79, 96
Mana Fashion Services
 47–8, 61
Mana, Moishe 48
Mann, Michael 90
Mantilla, Christy 58
Marshall, Mal 37
Maybach 80, 133
McCollough, Jack 56
Metaverse Fashion Week 143
Miami
 Art Week 142, 144
 bass 132
 Beach 100, 118, 146
 Chamber of Commerce 29
 City Ballet 100
 City of the Future 90, 99
 Design District 47, 151
 Design Preservation
 League 100, 101
 Fashion Council 29
 Fashion Institute 47
 Fashion Week 48, 63, 146
 Grand Prix 79, 140, 145–6,
 145
 Heat 98, 99
 Herald 104, 108, 120, 129,
 140
 Seaquarium 124
 Swim Week 140, 146, 146
 Vice 6, 7, 23, 90–95, 90, 92,
 95, 96, 96, 98, 99, 100,
 118, 120, 124, 130, 132, 140,
 154
Midas of Miami 36
Mids Market Vintage &
 Thrift 152
Miller, Nicole 118
Mitchell, Shay 83

Moschino 114
Moss, Kate 124, 129
MTV Video Music Awards
 73, 73, 79
Mugler, Thierry 104

NB990V3 72
News Café 52, 120

Obsession 108
Oldham, Todd 52, 118, 118
Ordway, Doug 124
Orlon 42
Otis, Carré 109, 114, 116

Palm Angels 96
Parma, Marco 124
Penn, Sean 129
Pervert 72–3, 73
Pfeiffer, Michelle 81
Pharrell 84
Pippart, Gerard 114
Pommier, Michele 111
Prada, Agatha Ruiz de la 146
Proenza Schouler 56–7, 57

Ragazzi, Francesco 96, 98
Raleigh Hotel 98, 131
ready-to-wear 58, 58, 60
resortwear 20, 21, 23, 25, 26,
 52, 65, 68, 68, 83, 146
Ricci, Nina 114
Rodriguez, Pres 70
Rosalía 136, 144, 144
Ross, Rick 80, 132–3, 133
Rousteing, Olivier 6, 9, 96
Rowley, Cynthia 118
Ruiz, Rene 146
RuPaul 102

Saintil Tracey 146
Saks Fifth Avenue 19, 29,
 58, 150
Salcedo, Gabriel 61
Sanchez, Angel 146
Scarface 81, 81
Sears 29, 37
Sex 129

Shissler, Richard 95
Silver, Cameron 19
Smith, Will 131
Smith, Willi 142
Soto, Talisa 114
South Beach 6, 20, 52, 55, 55,
 73, 82, 84, 90, 100, 101,
 102–4, 102, 104, 108, 109,
 111, 111, 114, 114, 115, 117,
 120, 120, 124, 129, 130, 131,
 132, 152
South Beach Stories 124
sportswear 36, 42, 20
Stinky Rat 72
Stitch Lab 148
Stray Rats 70–2, 71
Stussy, Shawn 140
Styles, Harry 58, 60, 60
Sunshine Fashions 30, 31, 33
Surf Club 28

Taylor, Niki 111
Tcherassi, Silvia 62–3, 63
Teixeira, Duda 58, 58
Trick Daddy 132
Trina 132, 133
Tubbs, Ricardo 93, 95. 95
Turlington, Christy 111,
 124, 129
Tuttle, Julia 16
2 Live Crew 132, 135

Vanity Fair 30
Vargas, Kika 149
Versace 52, 93, 95, 104,
 118, 120–4, 120, 123, 129,
 131, 154
Vogue 23, 26, 29, 95, 109, 114,
 116, 120
Vuitton, Louis 142

Wade, Dwyane 96
Warsaw Ballroom 102, 102
Weber, Bruce 108, 114, 118
Whitman, Stanley 151
Williams, Esther 18
Williams, Robin 104

CREDITS

Much of the information in Chapter 1: The City That Style Built was sourced from the *Tampa Bay Times*, *Miami Herald* and *Burdine's: Sunshine Fashions & the Florida Store* by Seth Bramson.

The publishers would like to thank the following sources for their kind permission to reproduce the pictures in this book.

Alamy Stock Photo: Album 7; /Heritage Image Partnership Ltd 32-33; /Kestone Press 37; /Moviestore Collection Ltd 92; /Pictorial Press Ltd 91, 96; /Sipa US 53, 141

Bridgeman Images: HistoryMiami 28

Éliou: 59

FIU Archives: 27

Getty Images: 305pics/GC Images 11; /Slim Aarons 18, 25, 43; /H. Armstrong Roberts/ClassicStock 21; /Axelle/Bauer-Griffin/FilmMagic 97; /Pauline Ballet - Formula 1/Formula 1 via Getty Images 78; /Gysembergh Benoit/Paris Match via Getty Images 112-113; /Sam Bloxham/LAT Images 145; /Gustavo Caballero/Getty Images for Miami Fashion Week 63, 133; /Thomas Concordia/Getty Images for Miami Swim Week: The Show 147; /Aaron Davidson 137; /Julio Donoso/Corbis 110, 117, 156-157; /Arthur Elgort/Conde Nast via Getty Images 44-45, 83, 108-109, 116; /Eric Espada 98; /Fairchild Archive/WWD/Penske Media 115; /Ron Galella/Ron Galella Collection via Getty Images 128; /Graphic House/Archive Photos 111; /Paras Griffin 80; /Julien M. Hekimian/Getty Images For Karl Lagerfeld 69; /Manny Hernandez 119; /In Pictures Ltd./Corbis via Getty Images 102, 105, 107; /Jason Koerner/GC Images 83; /Jeff Kravitz/FilmMagic, Inc 73; /Jeff Kravitz/MTV VMAs 2020/Getty Images for MTV 79; /Jason Koerner 49; /John Letourneau/WWD/Penske Media via Getty Images 121; /Romain Maurice/Getty Images for Red DAO 143; /Marmagnum 154-155; /Jamie McCarthy/Getty Images for W Magazine 77; /Pierre Mouton/Getty Images for Balmain 8; /Kourken Pakchanian/Conde Nast via Getty Images 24; /PG/Bauer-Griffin/GC Images 71; /Mark Peterson/Corbis via Getty Images 130; /Robert Phillips /Sports Illustrated/Getty Images 87; /Marc Serota 122-123; /Jim Spellman/WireImage 54; /Astrid Stawiarz/WireImage 144; /Art Streiber/Penske Media via Getty Images 125, 126, 127; /Alexander Tamargo/WireImage 85; /Alexander Tamargo/Getty Images for Zacapa Rum 149; /Andrew Toth 57; /United Artists 106-107; /Patrick Ward/Popperfoto via Getty Images 12-13, 101; /Matt Winkelmeyer 60

Courtesy JBQ: 67

Andrés Oyuela: 64

Shutterstock: Universal/Kobal 81

State Archives of Florida: 22, 31, 38-39, 40-41, 46

Topfoto: 17